# UNFORGETTABLE
# TEXANS

# UNFORGETTABLE
# TEXANS
★

*Bartee Haile*

THE
History
PRESS

Published by The History Press
Charleston, SC
www.historypress.net

*Front cover, top left*: DeGolyer Library, Southern Methodist University, Lawrence T. Jones
Texas Photographs; *top right*: RG5F0506b-03, Houston Public Library, HMRC; *bottom left*:
RGD0005F2013, Houston Public Library, HMRC; *bottom right*: MSS399-17, Houston Public
Library, HMRC.
*Back cover*: RGD5F4392-07, Houston Public Library, HMRC; *inset*: RG05F968-01, Houston
Public Library, HMRC.

First published 2017

Manufactured in the United States

ISBN 9781467137737

Library of Congress Control Number: 2017934944

*To the young Texans of today, especially my granddaughter Lila, with the hope you will never forget the Texans who came before you.*

# CONTENTS

# CONTENTS

# ACKNOWLEDGEMENTS

Vintage photographs and illustrations do not grow on trees. You need to know where to look for them, and I have learned that the best places are the Houston Metropolitan Research Center and the DeGoyler Library at Southern Methodist University in Dallas. I don't know what I would do without Timothy J. Ronk and Joel Draut at HMRC, as well as curator of photographs Anne Peterson and Katie Dziminski and Terre Heydari at SMU. I also want to thank a first-time source, Randy Vance, with the Southwest Special Collections Library at Texas Tech.

*Unforgettable Texans* is the result of my first collaboration with Ben Gibson, my new editor at The History Press. I think it helped that he is a fellow Texan and, even more important, that he knows his stuff. Ben was a pleasure to work with, and I look forward to doing more books with him.

My final thank-you goes to my wife, Gerri, for her vital contribution to the finished product. With each book, she has taken on a bigger role by doing everything from proofreading to editing to helping me decide which "forgotten" Texans made the cut and which ones didn't. Gerri did a wonderful job, and I am, as always, truly in her debt.

# INTRODUCTION

**W**hat makes some men and women memorable, while most are forgotten sooner or later? In Texas, the competition for our collective memory is understandably fierce. Our history was made by doers, people who came here from every state in the Union and more than a few foreign countries in search of something better—whatever that happened to be at the time. Whether they found it or came up short, their personal struggles are a part of the story of Texas.

For the past thirty-four years, I have written a weekly newspaper column about all kinds of Texans—the good and the bad, the famous and the infamous and many who were well known in life but have been forgotten in death. Those are the Texans whose stories I most enjoy telling, because I believe they deserve a little immortality just as much as Houston, Austin, Travis and the other icons of the Lone Star's past.

As the first governor of Texas, James Pinckney Henderson had every reason to expect twenty-first-century Texans to at least recognize his name. Yet how many can place him? The same goes for "Fabulous Tom" Ochiltree, without a doubt the best-known Texan of the late 1800s; Ad and Plinky Toepperwein, the husband-and-wife trick-shot wizards; Harper Baylor Lee, the very first gringo matador; Boyce House, the most popular Texas author for more than a quarter of a century; and John Boles, the star of stage and screen from the 1920s until the 1950s.

On the other side of the historical coin, there are once-prominent figures whose present-day obscurity is their just reward. No secessionist was more

zealous than Louis T. Wigfall, who gave Confederates, as well as Unionists, an incredibly hard time. Thomas Jefferson Chambers was a megalomaniac whose illusions of grandeur never matched the harsh reality of his self-absorbed existence. After spending six years as a despised outcast in the U.S. Senate because he owed his seat to the Ku Klux Klan, Earle B. Mayfield was shocked to learn that practically no one wanted him to be governor.

There are other "forgotten" Texans whose anonymity can be explained. Harley Sadler, the tent-show maestro, was a household name in the small towns and rural communities of West Texas but unknown in the cities. Edward Mandell House, the master of behind-the-scenes politics, shunned the limelight to such an extent that he inadvertently guaranteed future generations would never know he turned Woodrow Wilson into a president. James Otto Richardson and Hubert "Red" Knickerbocker were recognized as, respectively, the admiral who warned FDR about Pearl Harbor and the foreign correspondent who exposed Hitler and the Nazi menace—but they weren't recognized as native Texans even in their lifetimes.

Over the years, the question I am most often asked by readers of my newspaper column is how I find such interesting stories about Texans they never heard of. The answer is simple: I am always looking for people with an intriguing personal tale. When I do find them, my job is simply to let them tell their own story.

That's what I've tried to do with *Unforgettable Texans*. By the way, once you read about these Texans of yesteryear, they won't be forgotten anymore.

—Bartee Haile
November 2016

# THOMAS PECK OCHILTREE

## *Redheaded Ranger of the Rio Grande*

W ho was the best-known Texan in the United States and Europe in the 1890s?

Keep in mind that Houston, Austin and the rest of the San Jacinto generation were long dead and buried by the last decade of the nineteenth century. As for Governor James Stephen Hogg, the political giant of the period, his quaint surname rang few bells back east or overseas.

Give up? The answer is Thomas Peck Ochiltree (1839–1902), part-time politician and full-time bon vivant who, in his own words, "sucked the orange of pleasure dry" while extolling the infinite virtues of his adopted state as a colorful one-man chamber of commerce.

The life of the party never let the fact of his Alabama birth interfere with his claim that he was a native Texan. After all, Ochiltree argued, his father, for whom a Panhandle county is named, was a Lone Star Republic founder and brought him while still in diapers to the new nation.

Rebelling against parental plans for the priesthood, Tom ran away from home at sixteen and enlisted in the Texas Rangers. During an extended tour of frontier duty that featured hard-fought action against the Comanches and Apaches, the teenager earned the respect of his peers and the nickname "Redheaded Ranger of the Rio Grande."

Thanks to his influential father's string-pulling, Tom was granted a license to practice law by a special act of the state legislature despite having never cracked a law book. Upon joining the family firm, the practical joker revised the shingle: "T.P. Ochiltree and Father, Counselors and Attorneys at Law."

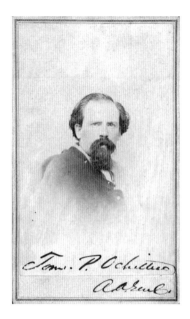

Tom Ochiltree was as popular in Texas as back east and abroad in spite of his ties with the Republican Party. *DeGolyer Library, Southern Methodist University, Lawrence T. Jones Texas Photographs.*

After the election of Abraham Lincoln in the fall of 1860, Tom started his own newspaper at Jefferson. The zealous publisher took the secessionist side in the charged debate over the future of the Union. "War is upon our borders," he warned in an editorial. "Hostile armies are marching down to subjugate us to abolitionism."

Making a tongue-in-cheek promise "to kill ten Yankees before breakfast and many hundreds more after a hearty meal," Tom traded his pen for a sword. He took part in the ill-fated invasion of New Mexico, winning several combat citations at the Battle of Valverde, where two horses were shot out from under him in a hell-bent-for-leather charge against the Federal lines.

Promoted to colonel four days before Robert E. Lee surrendered at Appomattox, Tom was taken prisoner and detained on an island in Lake Erie. But an old acquaintance, who happened to be a Northern general, learned of his predicament and prevailed on President Andrew Johnson to order his release.

Like untold thousands of Confederates devastated by the disastrous defeat, Tom's gut reaction was to go abroad rather than knuckle under to the victors. But a melancholy summer in Europe convinced him that exile was masochistic madness; by September 1865, he was back home in occupied Texas.

"Why should I grieve over the past and add my wailing to those of the great multitude?" he asked in the pages of a Houston newspaper that hired him as editor. Resolving to "make the best of a bad thing," he stated that his personal mission was to promote sectional understanding and to "create cheerfulness in the ranks of a fallen people."

Tom discovered to his dismay that fellow Texans were unwilling to forgive, much less to forget; under the circumstances, he could hardly blame them. The wounds of war were already being infected by the nine-year punishment euphemistically called Reconstruction and would take generations to heal. The sheer power of the unfolding tragedy ground his good intentions into dust.

Tom cut short his unhappy homecoming and headed for Washington, D.C., where he made an important new friend. General Ulysses S. Grant was so impressed with the charming Texan that he arranged for full restoration of the former foe's citizenship. Armed with letters of introduction from a who's who of Northern notables, the twenty-seven-year-old journalist embarked on the first of five dozen European excursions.

When Tom returned to Texas in 1868, he threw himself heart and soul into the Grant-for-president campaign. Though motivated in part by gratitude, his wholehearted support for the former commander of the Northern armies was based primarily on the belief that his moderate benefactor would scrap the vindictive agenda of the Radical Republicans and improve conditions in the conquered South.

Tom's distinction between the different brands of Republicanism was lost on most Texans, who despised the GOP as the party of carpetbaggers, scalawags and emancipated slaves. His efforts on behalf of the controversial candidate provoked countless confrontations and at least one bloody brawl that landed an antagonist in intensive care.

Grant waited until his second term to reward the brave backer with an appointment as a federal marshal. When Tom helped to persuade the president in 1874 not to send troops to keep Edmund J. Davis, the hated Reconstruction governor, in office, Radicals demanded his removal. Tom eventually resigned, but only after surviving a Senate vote of no confidence and telling Grant that he had at last been bested by a Reb.

Except for a single congressional term in the 1880s, Tom spent the next three decades as a highly paid lobbyist and freelance writer on any subject of his choosing. Shuttling between Washington, New York and Europe, he rubbed shoulders with the rich and famous on both continents.

Ordinary Americans were delighted by his irreverent escapades. When Tom serenaded Queen Victoria with an off-key rendition of "John Brown's Body" and invited the Prince of Wales to share a drink with him, stuffy diplomats were mortified. But the public loved it and packed a Broadway theater for every performance of a play based on his amazing adventures and bet their hard-earned money on a thoroughbred racehorse the owner named "Tom Ochiltree" in his honor.

Texans were no less fascinated by Tom's front-page exploits and readily forgave his Republican indiscretion. The legislature adjourned on the spot in 1895 when word reached lawmakers that "Fabulous Tom" was in town. The unique opportunity to shake the hand of the homegrown celebrity took precedence over the boring affairs of state.

Four years later, flames threatened Tom's suite in a New York hotel. His loyal valet pulled him to safety and went back for his master's treasure trove of personal letters, only to be clubbed unconscious by a cop who mistook him for a looter.

Tom Ochiltree died in 1902 following a long illness. He could not have asked for a more flattering epitaph than this compliment once paid to him by a devoted admirer: "I have never met a more charming man. He has met everybody worth meeting, has seen everything worth seeing and comes about as near knowing everything worth knowing as any man I ever heard of."

In the Lone Star State, however, Tom was most fondly remembered for his tall Texas tales. On an especially memorable occasion, he employed his razor-sharp wit to take the wind out of a British blowhard's sail. A self-important explorer described for a gullible audience his recent find of a petrified forest in darkest Africa. He claimed that, in addition to the trees, lions and elephants had also turned to stone.

"Texas has its petrified forests," Tom observed dryly. "Although they contain no petrified lions, they are remarkable for having petrified birds flying over them."

"Nonsense!" objected the Englishman, taking the bait. "Such a phenomenon is contrary to the laws of gravitation!"

"Ah, that's easily explained," replied Tom with a straight face. "In Texas, you see, the laws of gravitation are petrified, too."

# 2
# JAMES OTTO RICHARDSON

*Did Admiral See Pearl Harbor Coming?*

For those generations born before and during the Great Depression, December 7, 1941, was their 9/11. On that Sunday morning, the Japanese launched a surprise attack on Pearl Harbor in the Hawaiian Islands that crippled the U.S. Navy's Pacific Fleet, killed 2,403 Americans, almost exclusively naval personnel, and propelled the United States into World War II.

In the seventy-five years since that "day of infamy," there have been innumerable attempts to pin the blame for the Pearl Harbor calamity on somebody, even President Franklin Roosevelt by some conspiratorial critics. One major figure that history has exonerated is Admiral James Otto Richardson (1879–1974), who firmly believed the ships of the Pacific Fleet were sitting ducks.

Joe Richardson was born in Paris in 1879, and that Northeast Texas town was where he grew up and attended public school. A brilliant student, he received a highly coveted appointment from his congressman to the U.S. Naval Academy.

Before his departure for Annapolis, his father, a former captain in the Confederate army, told him, "Son, you can't expect to compete with those Northern boys in the naval academy. There's something about this Texas sun that dries up your brain."

Determined to prove his pappy wrong, Richardson hit the books night and day. His effort and dedication to his studies were rewarded in 1902, when he graduated fifth in his class of eighty-five.

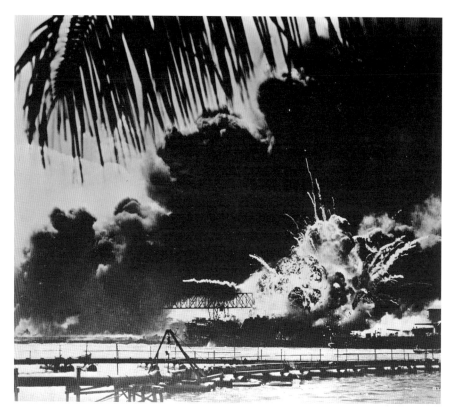

The destruction of the Pacific Fleet and the loss of more than two thousand American lives at Pearl Harbor might have been avoided if FDR had taken Admiral James Richardson's advice. *Library of Congress.*

Fresh out of the academy, the junior officer took part in the Philippines campaign, which was the final phase of the Spanish-American War in the Pacific. In 1905, he changed oceans and spent two years in the Atlantic as commander of the torpedo boats *Tingey* and *Stockton*. In 1909, he returned to his alma mater for two years of postgraduate studies in the new engineering school.

After World War I duty as navigator and executive on the battleship USS *Nevada*, the Texan "saw the world" with a succession of assignments. By 1931, he was a captain in charge of a brand-new heavy cruiser. His steady rise in the ranks for the rest of the Depression decade led to speculation by those in the know that FDR was personally grooming him for the upper echelon.

Richardson reached the top in January 1940, when his temporary rank of admiral was made permanent with his promotion to Commander in

Chief, United States Fleet. No sooner had he taken charge than President Roosevelt ordered him to move the Pacific Fleet to Pearl Harbor from its longtime base in San Diego.

"It was Richardson's belief," historian Joe Flynn ventured in *The Final Secret of Pearl Harbor*, "that the Fleet should never be berthed inside Pearl Harbor where it would be a mark for attack. What is more, Richardson held the belief that Pearl Harbor was the logical first point of attack for the Japanese High Command, wedded as it was to the theory of undeclared and surprise warfare."

If the navy had an "in-house" expert on the Japanese military, it was Joe Richardson. While a student at the U.S. Naval War College in 1934, he had written an impressive thesis entitled "The Relationship Between Japanese Policy and Strategy in the Chinese and Russian Wars, and Its Lessons to Us."

But the people who would have most benefited from reading his paper evidently never did. As Richardson pointed out in his autobiography,

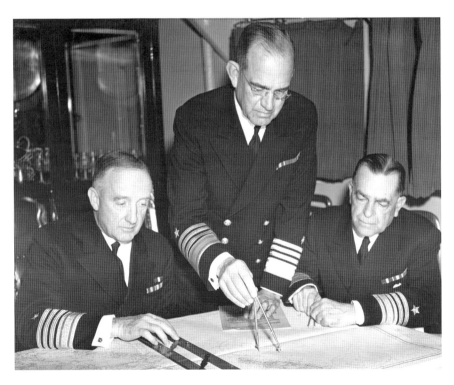

Admiral James Otto Richardson (*standing*) studies a map with two subordinates. *RGD5F4392-07, Houston Public Library, HMRC.*

finished in 1958 but withheld from publication until 1973: "In 1940, the policy-making branch of the Government in foreign affairs—the President and the Secretary of State—thought that stationing the Fleet in Hawaii would restrain the Japanese. They did not ask their senior military advisors whether it would accomplish such an end. They imposed their decision upon them."

Ironically, planning for the sneak attack on Pearl Harbor began in Tokyo in January 1941—the same month the Roosevelt-Richardson dispute came to a head. The president had reacted to the recent Japanese invasion of French Indochina by putting an embargo on scrap-metal shipments to Japan and closing the Panama Canal to all oceangoing vessels flying the Rising Sun. With the loss of 74 percent of their scrap iron in addition to 93 percent of their copper, the Japanese felt that war with the United States was inevitable and imminent.

In early October 1940, Admiral Richardson made the long trip from Hawaii to Washington, D.C., to present his point of view in person to the president. Though visibly annoyed by the criticism, Roosevelt politely heard him out before restating his own position that war with Japan would not happen anytime soon. He went so far as to say that even if the Japanese invaded the Philippines, a U.S. territory, he would exercise restraint and wait for a more opportune moment to take them to task militarily.

Richardson realized that he was risking his career by requesting a second meeting with Roosevelt three months later, in January 1941. He told him point-blank: "Mr. President, I feel that I must tell you that the senior officers of the Navy do not have the trust and confidence in the civilian leadership of this country that is essential for the successful prosecution of a war in the Pacific."

That was the last straw as far as FDR was concerned. He immediately relieved Admiral Richardson of his command and offered it to Chester Nimitz, a fellow Texan who had been three years behind Richardson at the naval academy. Nimitz wisely turned down the assignment without angering the president.

Richardson was demoted to the permanent rank of rear admiral and put on desk duty until his involuntary retirement in October 1942. His four decades in the navy officially ended five years later with his release from active duty.

Even though Richardson feared the possibility of a sneak attack on Pearl Harbor by the Japanese, he, too, was shocked by the fact that it was delivered by aircraft carriers and by the devastating blow the Pacific Fleet sustained.

Never had he imagined that four of the eight battleships would be sunk and the other four badly damaged, and that Japanese pilots would also sink or damage three cruisers, three destroyers, an antiaircraft training ship and a minelayer while destroying 188 airplanes.

Richardson was still in uniform when Secretary of the Navy James Forrestal "sent for me and told me that he was not satisfied with the report of the Naval Court of Inquiry on Pearl Harbor or with any preceding inquiry, and that he had so stated in the press, adding he would have another investigation made."

> *He then stated that he would like to have me undertake the investigation for him. I said, "Mr. Secretary, I am sorry but I am not available for such [an] assignment because I am prejudiced and I believe that no prejudiced officer should undertake the inquiry."*
>
> *The secretary asked what I meant by the statement that I was prejudiced, and I replied, "I am prejudiced because I believe that any fair and complete investigation will result in placing a part of the blame for the success of the attack upon the President."*

Secretary Forrestal dropped the matter, and Richardson played no part in the subsequent inquiry.

Joe Richardson lived out his days in semi-seclusion in the nation's capital, where he passed away in 1974 at the age of ninety-four. Today, it is hard to find anyone who remembers the admiral from Texas who saw Pearl Harbor coming.

# 3

# THE WHARTONS

## *Tragedy Stalked Texas Clan*

**W**illiam Harris Wharton (1802–1839) and John Austin Wharton (1806–1838) found themselves orphans at ages fourteen and ten, respectively, after the sudden deaths of both parents in 1816. A big-hearted uncle in their hometown of Nashville, Tennessee, opened his home to the boys and three other siblings. Jesse Wharton not only kept the children together but also provided each of them with a first-rate education.

William and John, gifted students, earned undergraduate and law degrees and admission to the bar in their early twenties. The older Wharton was the first to migrate to Texas, coming in 1826. The date of John's arrival is in dispute, with some historians claiming he followed in 1829 and others contending he waited until 1833.

By the time John did appear on the scene, his big brother was leading the charge for independence. The younger Wharton started a newspaper, the *Advocate of the People's Rights*, to provide William with a platform for presenting his radical views. The focus of the firebrand's attacks was none other than Stephen F. Austin, whom William relentlessly raked over the coals for his conciliatory attitude toward the Mexican government. The war of words culminated in a duel between John Wharton and William T. Austin, a distant but combative relative of the future "Father of Texas." In the traditional "affair of honor," John was shot in the wrist; he never regained full use of his hand.

The feud had cooled only a few degrees by the fall of 1835, when Sam Houston called William H. Wharton and Stephen F. Austin away from the

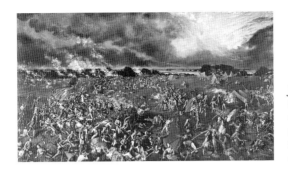

John Austin Wharton was eulogized as "the keenest blade" at the Battle of San Jacinto. He is shown here in the 1895 painting of the same name by Henry Arthur McArdle. *Wikipedia.*

siege of San Antonio. He talked them into temporarily putting aside their differences and joining Branch T. Archer on a mission to the United States to raise money and political support for the Texas Revolution.

That was why William missed San Jacinto and John's heroics in the tide-turning battle. But with the Republic of Texas finally recognized by President Andrew Jackson on his last day in office, the diplomat was free to return home in time for the first anniversary of Lone Star independence.

It took William an exhausting month to reach New Orleans, where he hopped a ride on the *Independence* for the last leg of his journey. A week out of the Crescent City, Wharton saw the mouth of the Brazos River through the morning mist. That meant Velasco, his ultimate destination, was just four miles down the coast.

Without warning, two Mexican warships came into view and headed straight for the *Independence*. The horrified inhabitants of Velasco watched helplessly from shore as the pride of the Texas Navy was boxed in and boarded.

The sailors and their civilian passenger were taken prisoner and transported to Matamoros for indefinite detention. John Wharton immediately went to Sam Houston and demanded to know how he planned to obtain his brother's release. But the president explained that there was little he could do given the state of war that still existed between Texas and Mexico.

Upset by the inaction of her own government, Sarah Ann Wharton decided to go over Houston's head by making a direct appeal to Washington. Bravely setting out on horseback, she broke a leg in a bad fall before reaching the border.

Beside herself with worry, she waited weeks for word from her husband. When William was at last allowed to write a letter home, he assured his anxious wife he was alive and well and added that the Mexicans seemed open to a swap.

Houston eventually gave in to pressure from the captive's kin, agreeing to pay for a rescue ship and to hand over thirty San Jacinto prisoners of war

in the exchange. John Wharton located a suitable schooner and sailed south late that summer.

As the brother waited off Matamoros for permission to enter the hostile port on the night of October 2, 1837, a gale blew the small ship aground. On the streets of the border town the next morning, the soaked survivors bumped into Father Michael Muldoon. The former priest of the Austin colony found the hunted Texans a place to hide and something to eat while he tried to devise a way to get them out of Mexico.

From his host, John Wharton learned that his brother had long since escaped. Muldoon had supplied the clerical costume that enabled William Wharton to walk out of jail disguised as a priest.

If the fearless friar had any second thoughts about risking the Mexicans' wrath one more time, he kept them to himself. Within the week, Muldoon managed to spirit John Wharton and his companions out of Matamoros and across the Rio Grande.

Thirteen months later, John Austin Wharton took sick and died of what was vaguely described as the "fever." He was thirty-two years old. In his eulogy, David G. Burnet, caretaker chief executive of the Texas rebellion, solemnly said, "The keenest blade of San Jacinto is broken."

William Harris Wharton did not live long enough to come to terms with the death of his brother. Three months after laying John to rest, he was fatally wounded by the accidental discharge of his own pistol while climbing down from his horse.

John Austin Wharton, the son whom William named after his beloved brother, was only ten when his father and uncle perished. But the second John Austin did the famous family proud. He went away to college in 1846 and came back four years later with a degree and the daughter of the South Carolina governor as his bride. When the political pot finally boiled over a decade later, the successful attorney and prosperous planter was already set for life.

But duty called, and Wharton answered by joining Terry's Texas Rangers. Following the deaths of the cavalry cofounders Benjamin F. Terry and Thomas F. Lubbock, he assumed command and rose to the rank of major general on the strength of his bravery and brilliance.

Reassigned to Louisiana in the winter of 1864, General Wharton played an important part in thwarting the Union invasion of Texas. The weary warrior might have taken a moment to savor the sweet victory at Mansfield had he known the South was destined to dine on a steady diet of defeat.

Lee's Appomattox rendezvous with his alcoholic adversary was just three days away on April 6, 1865, but Wharton was too preoccupied with preparations for the last-ditch defense of his home state to worry about what was happening in faraway Virginia. Like most Confederates out west, he had resolved to fight on in spite of the expected surrender.

Brigadier General James E. Harrison was at the controls of the buggy carrying Wharton to the Houston depot that fateful morning. Recognizing one of two approaching officers as Colonel George Wythe Baylor, the major general told the driver to stop and called out, "Where is your command?"

"Near Hempstead," Baylor answered with unmistakable disrespect. Wharton's face darkened as he growled, "You had better be with it."

A heated exchange ensued and quickly escalated into a shouting match. Caught in the verbal crossfire, poor Harrison did not have a clue as to the root cause of the conflict.

When Wharton ordered Baylor to report to his headquarters under arrest, the defiant subordinate retorted, "I will see General Magruder and have justice."

"You will report to him as under arrest," corrected his superior.

According to Harrison's statement at the subsequent inquest, the war of words raged on, with Baylor warning that the day was coming when they would be "on equal ground"—a clear reference to the imminent end of the war and their return to civilian lives. This transparent threat was followed by a punch aimed at Wharton's face that missed the mark only because Harrison alertly snapped the reins and moved the target out of range.

Harrison and his agitated passenger went on to the station and boarded the train. After brooding over the matter for several minutes, Wharton announced that he was staying in Houston to settle things with Baylor. Harrison had no choice but to accompany him to Magruder's headquarters.

General John Bankhead Magruder was eating breakfast at the Fannin Hotel when Baylor barged in "so much excited that he wept as he spoke." The Confederate commander of Texas left the incoherent colonel in a private room upstairs with stern instructions to pull himself together.

Wharton was looking for Magruder when he opened the door and found Baylor sitting on the side of the bed. The quarrel resumed, and Wharton moved toward his antagonist with fists clenched.

Intent on preventing a fight, Harrison stepped between the two men. As he did, Wharton took a swing at Baylor, who ducked and pulled his pistol. Harrison pushed Wharton away with one hand while grabbing the gun with the other, but he could not stop Baylor from squeezing the trigger.

The ball entered Wharton's torso slightly below the rib cage, and he dropped to the floor. He groaned twice and died before a doctor could be summoned. John Austin Wharton was the last of his line; the family name died with him.

The fact that Major General Wharton was unarmed seemed to make it murder in anybody's book. The chaotic collapse of the Confederacy precluded a military court-martial, but the case did go to trial in a civilian court three years later.

Breaking with the hang-'em-high tradition of frontier justice, the jury acquitted George Wythe Baylor. At his death in 1916, he was far better known as an Indian-fighting Texas Ranger than the killer of John Austin Wharton. But Baylor did have fifty-one years to think about the senseless slaying he called his "lifelong sorrow."

# JOHN BOLES

## *From Spy to Leading Man*

John Boles (1895–1969) grew up in Greenville, Texas, the city of his birth. He spent his summers with his grandparents, who realized early on that the boy was blessed with a wonderful singing voice and encouraged him to develop the marvelous gift.

Boles loved to sing and all through high school gladly did so at the drop of a hat. But his parents had their son's life all mapped out for him, and when the time came to go off to college, it was to prepare for medical school or the family bank.

He graduated with honors from the University of Texas in June 1917 and, two days later, married his college sweetheart, a Tyler rose. World War I had moved up the wedding date, and Boles, like most able-bodied men of his generation, joined President Woodrow Wilson's crusade to "make the world safe for democracy."

The Texan's fluency in French and German kept him out of the trenches, a deathtrap for millions in the European bloodbath. He was recruited by the Army Intelligence Service and sent behind enemy lines to spy on the Germans, Bulgarians and Turks. He survived the hazardous missions without so much as a scratch, a tribute to his ability to keep a cool head under dangerous and demanding conditions.

Back home in Greenville after the armistice, Boles heard that famous vocal coach Oscar Seagle was going to be in Austin. He rushed to the capital city and arranged a private audition with the maestro. Seagle was so impressed that he invited the baritone to study with him in upstate New York. Thrilled

by the once-in-a-lifetime opportunity, Boles borrowed $1,000 from his father, who wisely chose not to stand in his way, and moved with his bride to the Adirondack Mountains.

After teaching the promising pupil everything he knew, Seagle urged Boles to continue his studies in Paris. The easy thing would have been to hit up dear old dad for more money, but Boles earned the cash himself by giving students in a New York high school French and singing lessons.

Accompanied by his wife and their baby daughter, he spent two full years in Paris with the renowned Jean de Reszke, who, like Seagle, nurtured the Texan's natural talent. "I'll always think of that as one of the highlights of my life," Boles revealed in a 1935 interview. "The chance to come under the training of a great teacher and a greater philosopher."

Returning to the United States in 1923, Boles decided to try his luck on Broadway. In a mere three months, he landed the male lead in the hit musical *Little Jesse James*. After the show closed, he made his screen debut in *So This Is Marriage?*, which Metro-Goldwyn filmed in Manhattan. Strange as it may seem for a singer to appear in a silent picture, it was his well-proportioned good looks that opened the door to a second career. He made one or two more movies before returning to the stage in early 1925.

Gloria Swanson, the silent-screen superstar, saw Boles the next spring in the musical *Kitty's Kisses* and announced that she wanted him for her leading man in her first feature for United Artists. In the beginning, studio bosses went along to oblige the office-box queen but later were so taken with the singer's performance in *The Love of Sunya* that they signed him to an exclusive contract.

Boles packed up his growing family, which now included a wife and two girls, and moved to California. He played a variety of mostly forgettable parts before being cast in Hollywood's very first musical, *The Desert Song*. The reviews were unanimously positive; even the understated critic for the *New York Times* called his voice "quite pleasing."

Boles was not shy about acknowledging his debt to Swanson. "'The Love of Sunya' made certain film nabobs aware of my existence and led to me being cast in 'The Desert Song' the next year. I've got a lot for which to thank gorgeous Gloria."

Boles's parent studio loaned its suddenly hot property to RKO for the lavish 1930s musical *Rio Rita*. His costar was Bebe Daniels, as British as fish and chips but technically a Texan, since her birthplace was Dallas.

Boles made one musical after another that year, including *Song of the West*, *Captain of the Guard* and *King of Jazz*. When the time came to shoot the third

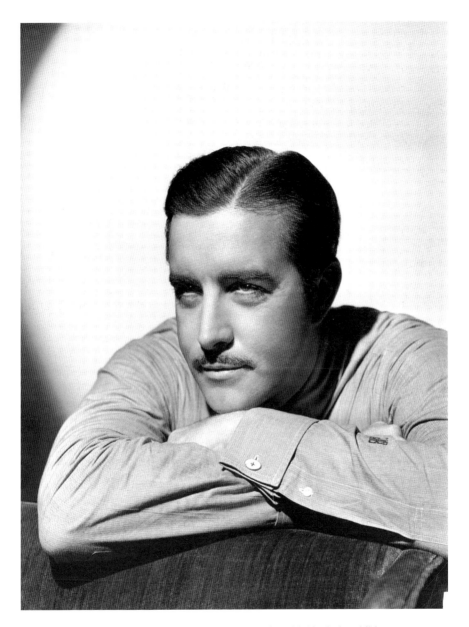

As this 1930s studio photo shows, John Boles had matinee idol looks in addition to a great singing voice. *RG5F0506b-03, Houston Public Library, HMRC.*

show's hit song, "It Happened in Monterrey," he filled in for Bing Crosby, who was in the drunk tank after an overnight DWI arrest.

Audiences soon tired of musicals, and in 1931, Boles sang his last on-camera note. That did not mean, however, that he was through with motion pictures.

It helped that Boles was not too picky about his parts. A supporting role in the original *Frankenstein* followed by three Shirley Temple vehicles—*Stand Up and Cheer, Curly Top* and *The Littlest Rebel*—in fact turned out to be career-boosting choices.

Boles was not limited to starring in horror flicks and working with child stars. For a number of years, he was the first choice of directors for an attractive middle-aged actor to play the subdued sophisticate opposite strong leading ladies like Irene Dunne (*Back Street*), Rosalind Russell (*Craig's Wife*) and Barbara Stanwyck (*Stella Dallas*).

After making more than fifty movies and earning a peak salary of $50,000, a first for a film actor, Boles saw the quality and frequency of his roles gradually diminish in the late 1930s and early 1940s. Facing the fact that his best days in Hollywood were behind him, he went back to where he started—Broadway.

He wasted no time in showing that he could still sing with the best of them. Paired with fellow Texan Mary Martin of Weatherford, he brought the house down in the 1943 production of *One Touch of Venus*, a hit musical that ran for more than five hundred performances.

Taking a break from Broadway after World War II, Boles followed in the footsteps of other aging stars on the "supper room" circuit. "I'm sort of a wandering troubadour," he said with a smile in 1947. "I sing a couple of songs at night and then sit beside a beautiful swimming pool all day. What's wrong with that?"

After a ten-year absence from Tinseltown, Boles made his last picture in 1952. In *Babes of Baghdad*,

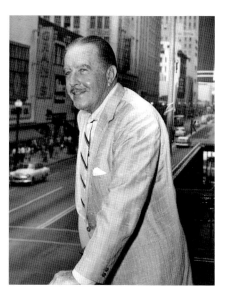

In this 1959 photo, John Boles stands on a balcony in downtown Houston overlooking Main Street. *RG5F0506b-05, Houston Public Library,* HMRC.

he was cast as a polygamous caliph who gives up all his wives save one and grants equal rights to his harem. Not his best work by a long shot!

Boles came home to the Lone Star State and settled in San Angelo, where he could keep a close eye on the shrewd investments that assured him a worry-free retirement. "At least they won't have to be giving any benefits for me," he modestly explained to an inquisitive reporter. "When my career started to slow down, I didn't want to sit around. So when the opportunity came to get into the oil business, I jumped at it.

"I enjoyed my acting career, every minute of it. I enjoy the oil business too. It's also busy and exciting. I like Texans. They think big."

A heart attack brought the curtain down on John Boles's fascinating life in February 1969. It was only fitting that on the death certificate his occupation was listed as "movie actor," but one wonders how he might have filled in that particular blank.

# THE SLICKS

## Wildcatter Father, Renaissance Son

On the surface, the only thing Tom Baker Slick Sr. (1883–1930), the original "King of the Wildcatters," and his son Tom Jr. (1916–1962), a true Renaissance man with an abundance of talents and interests, appeared to have in common was their name. But on closer examination, it is clear that the Slicks shared a consuming ambition to leave their mark in radically different fields.

Tom Slick (he was not yet a "senior") left his native Pennsylvania in 1904 and headed for Oklahoma, where employment prospects for a twenty-one-year-old with no experience were much better than back home. He talked his way into a job as a "lease man" with Spurlock Petroleum, which had done well for itself in Kansas and was looking to find even more underground riches in the Oklahoma Territory.

Alexander Massey took his new hire to Tryon in the dead center of the soon-to-be Sooner State and turned him loose. "Tom would go out and lease most of a territory as yet unproved or doubtful as to oil prospects," Massey would later recall. "But he'd spread as clean a bunch of leases before a capitalist as you'd wish to see. He certainly knew what a good oil lease was."

Slick did not, however, display the same knack for picking a spot to drill as he did convincing farmers to sign on the dotted line. After three years as Massey's "lease man" and one expensive "dry hole" drilled on his say-so, he went to work for Shaffer & Smathers in Chicago. Slick's new boss paid better—one hundred dollars a month plus expenses—but Slick extended his losing streak with ten more "dry holes."

The lease man's lousy luck did not go unnoticed at Bristow, southwest of Tulsa, where the local newspaper noted that he "continues to gamble on wildcat stuff. Few men have stuck to the wildcatting longer and harder than Slick and associates. It is said he had spent $150,000 mostly on dry holes." But Slick held tight to his unshakeable belief that time was on his side. Sooner or later, he would strike it rich, so why not in the town of Cushing in late 1911?

For once, the wildcatter had the newspaper on his side. The *Cushing Independent* urged readers to take advantage of the once-in-a-lifetime opportunity: "Land owners have everything to gain and no risk to themselves in making leases. It costs from $8,000 to $10,000 to put down a single hole. Unless the promoters can get the leases they want they will not chance their money here, while other localities are eager to give leases and even bonuses in money to get prospecting done."

Operating in the strictest secrecy so as not to tip their hand, Slick and Charles Shaffer began drilling an exploratory well sometime in January 1912 on Frank Wheeler's farm. On March 12, Wheeler No. 1 came a gusher, Tom Slick's first, signaling the discovery of an enormous oilfield. The *Star* at Tryon saluted the dramatic change in the wildcatter's fortunes: "Our old friend Tom Slick the oilman has struck it rich. Slick has been plugging away for several years and put down several dry holes. He deserves this success and here's hoping that it will make Tom his millions."

The Wheeler gusher and the many others that followed over the next eighteen years did just that. The Drumright-Cushing Field, which got its start on the Wheeler farm, was a big producer for the next thirty-five years, pumping 330,000 barrels a day at its peak. By 1929, the daily output of Slick's wells exceeded 35,000 barrels. No one could say for sure how much the "King of the Wildcatters" was worth, but estimates ranged from $35 to $100 million.

Tom Slick was still going great guns with no end in sight when he suffered a fatal stroke in August 1930 at the age of forty-six. According to the Oklahoma Historical Society, "Oil derricks in the Oklahoma City Field stood silent for one hour in tribute." In his will, Tom Sr. left $15 million apiece to his two sons, Tom Jr., fourteen, and his younger brother Earl. In present-day terms, the Slick boys' inheritance was worth approximately $200 million each.

The sister of Bernice Slick, Tom Sr.'s widow, was married to Charles Urschel, a wealthy Oklahoma City oilman. After she died in 1931, Urschel married his sister-in-law, Tom Slick Sr.'s widow.

On the night of July 22, 1933, "Machine Gun" Kelly and his gang abducted Urschel from his front porch. The kidnapping was front-page news for weeks until FBI agents raided a farm in north Texas and freed the hostage.

The media frenzy surrounding the case and subsequent trial of Kelly and his accomplices caused Tom Jr. to keep a low public profile for the rest of his life. But with his diverse interests and investments, as well as famous friends like Howard Hughes and actor Jimmy Stewart, that often proved impossible.

Tom Jr. inherited more than a fat bank account from his rich namesake. "Dad stressed the importance of using our time, energy and money to benefit others. Perhaps he was afraid my brother and I would be playboys. I learned at an early age the responsibilities that go with wealth."

Three years after graduating from Yale with a degree in biology, Tom the younger established the second-largest privately endowed research facility in the world, fifteen hundred acres on the outskirts of San Antonio. For the past seventy years, the Southwest Research Institute has blazed an impressive trail in a wide range of scientific fields. He also created the Foundation of Application Research (later renamed the Texas Biomedical Research Institute), the Institute of Inventive Research, the Southwest Agricultural Institute, the Mind Science Foundation and the Human Progress Foundation.

When not tending to his many enterprises, which included Slick Oil and Slick Airways, Tom took off on exotic odysseys to remote corners of the globe. His holidays were, however, sometimes harrowing. On a flight to South America to study an aboriginal tribe, his plane went down in the trackless Amazon. Given up for lost after a weeklong search, the world traveler and his entire party emerged unscathed from the dangerous jungle.

Meanwhile, the Abominable Snowman, or Yeti, was the subject of sensational stories in the Western press. Since the original sighting in the mid-nineteenth century of a "hairy, tailless wildman," tantalizing tales of the elusive creature had regularly filtered out of Nepal and Tibet. Fueling the latest round of speculation was a secondhand report passed on by Tenzing Norgay, the Sherpa guide who scaled Mount Everest with Sir Edmund Hillary in 1953. According to the famous native climber, his father once stumbled upon the legendary "missing link," which "looked like a big monkey or ape, except that the eyes were deeply sunken and its head was pointed at the top."

Acting on Tenzing's tip, the *Daily Mail* of London sponsored a headline-generating survey of the highest mountain range in the world. The empty-handed outcome of the expensive excursion provoked this rhyme from the

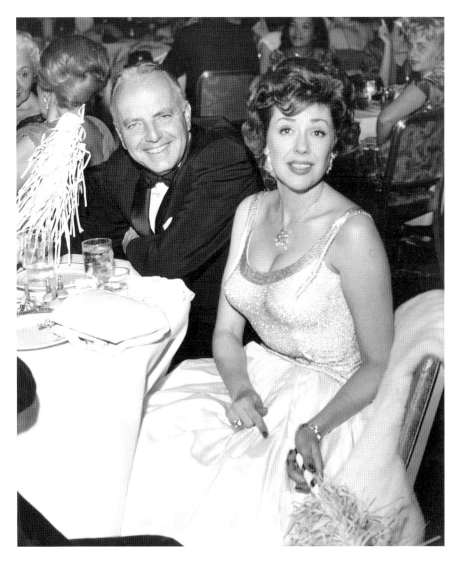

Busy as he was, Tom Slick Jr. always found time for beautiful women, like actress Marie "The Body" McDonald. *RGD0005F2013, Houston Public Library, HMRC.*

British humor magazine *Punch*: "There were fascinating footprints in the snows of Kathmandu on a slightly less than super-human scale; there are numerous conjectures on the owner of the shoe and the money it has cost *The Daily Mail.*"

If Tom Slick feared similar public ridicule, he never let it show. Displaying the same determination shown by the father in his hunt for oil,

the son launched his search for the Yeti. He plunged ahead with elaborate preparations for the first-ever scientific effort to determine whether the Abominable Snowman was fact or fantasy.

The net result of the 1957 expedition was three sets of human-like tracks, excrement samples and several strands of hair. The highlight of a return trip the next year was the unsubstantiated claim by two sherpas of a close encounter with a skittish snowman. After a third trip to Nepal in 1959 yielded no more hard evidence than the previous two, the Texan gave up the costly quest.

Friends and associates hoped Tom at last had gotten the wanderlust out of his system and would finally settle into the role of respectable executive. But the gypsy stopped off in San Antonio, his hometown and base of operations, only long enough to pick up a change of clothes.

The head of one of his scientific think tanks voiced his concern over the high-risk lifestyle of the restless "Renaissance Man." Tom replied with a mischievous smile, "Don't worry so much about the hopping around I do in small planes in foreign countries and in mountains looking for the Snowman or mines or even hunting. I have a million-dollar insurance policy with the institutions as beneficiary."

But the intrepid traveler ultimately took one chance too many. Returning from a Canadian hunting trip, he was caught in a severe storm over Montana in October 1962 and plunged to his death along with the pilot of the undersized aircraft. In an ironic coincidence, he died at forty-six— exactly the same age as his father.

Tom Slick Jr. bequeathed $12 million to three of his beloved research institutes and a trio of Lone Star colleges. Texas Christian and Texas A&M received hefty checks, as did the LBJ School of Public Affairs at the University of Texas for the pursuit of world peace.

The Slicks may have been as different as daylight and dark, but Tom Sr. and Tom Jr. made the most of their abbreviated lives and did indeed leave their marks.

6

# THOMAS JEFFERSON CHAMBERS

## *"The Least Deserving of Mortals"*

If losers are made and not born, Thomas Jefferson Chambers (1802–1865) was truly a self-made man. Talented, educated and well-to-do, greatness seemed to be his for the taking. But an insatiable ego and a nasty habit of antagonizing everyone who crossed his path demoted him to a footnote in Texas history.

Llerena Friend, best known for her 1954 biography of Sam Houston, wrote her thesis on this early Texan so many of his peers loved to hate. "People seemed unable to trust him, believed him vacillating, an opportunist ready to support whatever group happened to be in power and could afford him the most advancement."

The baby in a brood of twenty children, Chambers was born in Virginia in 1802. He grew up in Kentucky, practiced law in Alabama and left for Mexico in the mid-1820s. He taught school for several years in the capital, learned to speak fluent Spanish and became a Mexican citizen. Recognizing the opportunity north of the Rio Grande, he came to Texas as surveyor-general for the central government.

Chambers wasted no timing in siding with the small minority of Anglo-American colonists critical of Stephen F. Austin. Acting as spokesman for the disgruntled clique, he regularly raked the selfless empressario over the coals and continued the public attack even during Austin's long imprisonment. The "Father of Texas" took to his early grave the strong belief that Chambers's backstabbing prolonged his hellish captivity.

Mexican officials, on the other hand, held Chambers in high esteem and in 1834 appointed him to the top judicial post in provincial Texas. Given

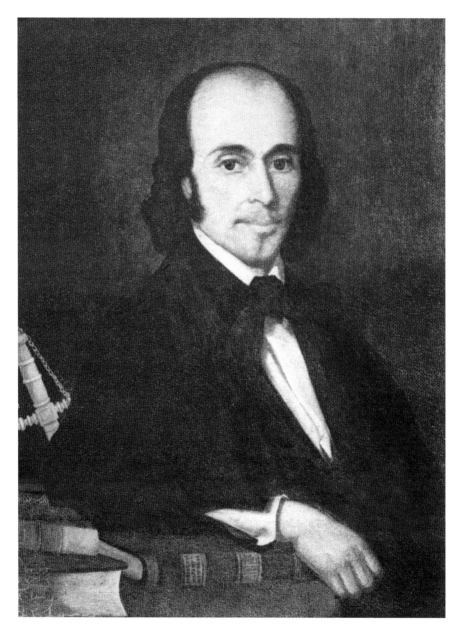

This portrait of Chambers in the prime of life was hanging on the wall of the parlor the night when he was murdered. Houston Chronicle *Vertical File, Houston Public Library, HMRC.*

his close ties with the host government, it was hardly surprising that he did not share the festering dissatisfaction of most settlers with the status quo. Furthermore, Chambers's comfortable position as a prominent landowner dampened any enthusiasm for radical change. Eight leagues of choice land along the Colorado River that he obtained in June 1835 increased his total holdings to more than 130,000 acres. To cast his lot with the rebels simply was not in his self-interest.

Only after the armed struggle broke out at Gonzales in October 1835 did Chambers, who had been denounced as a Tory by the General Council, jump on the independence bandwagon. But he did not let his late conversion to the cause nor his unexplained absence during the siege of San Antonio hold him back. He announced with his usual arrogance that he was best qualified to lead the uprising to victory.

Although the rebels did not flock to Chambers's banner, most kept their opinion of his outrageous declaration to themselves. No one wanted to risk losing his support and certainly not his money. After he was politely ignored for several months, Chambers offered in January 1836 to recruit and equip a contingent of American volunteers at this own expense. Unable to pass up such a bargain, the provisional regime created the "Army of Reserve for the Protection of the Liberties of Texas" and bestowed on Chambers the paper rank of major general.

Spending more than $20,000 from his own deep pockets, Chambers sent nearly two thousand would-be combatants to Texas between May and December 1836. Unfortunately, the fighting was over, and the restless recruits had little to do other than cause trouble.

Chambers suddenly showed up in June 1837 to make his case for commander in chief of the idle military, a post left vacant by Sam Houston's promotion to president the previous September. As the only remaining major general in the republic, he indignantly insisted the position was rightfully his.

In light of the well-known fact that Chambers had never held a combat command, the Congress flatly rejected his self-serving logic. David G. Burnet accused him of extending his stay in the United States to avoid the conflict with Santa Anna. Another observer, Attorney General Peter Grayson, labeled him "the most undeserving of mortals." A motion that the charlatan take charge of the army died for lack of a second.

Construction of the new capital was well underway before Chambers realized he held clear title to the site. His frantic and admittedly justified protest fell on deaf ears, and his heirs were not awarded token compensation until 1925.

After failing to unseat the incumbent in a race for the state legislature in 1849 and finishing fifth in the 1851 and 1853 gubernatorial elections, Chambers briefly bolted to the American Party, better known as the Know Nothings. Returning to the Democratic fold at the end of the decade, he tried to take center stage as the shrillest advocate of secession. At the state convention in February 1861, Chambers denounced Governor Sam Houston in a vile tirade before casting his vote for the Confederacy. Although the other delegates were equally as opposed to Houston's pro-Union stand, few could stomach such a vicious attack on the hero of San Jacinto.

Chambers showed himself to be a glutton for punishment by again running for governor in 1861 and 1863. But even a nobody like Pendleton Murrah, the winner in 1863, prevailed over the pathetic candidate. Between elections, Chambers made the long journey to Richmond, the Confederate capital, to seek a battlefield command. Denied a commission of any kind, he swallowed his pride for possibly the first time in his life and volunteered to serve as an officer's aide in Hood's Texas Brigade.

While recovering from a minor wound sustained during the Seven Days campaign in June 1862, Chambers tried to convince Jefferson Davis and his Confederate cabinet that he was a better choice to defend the home front in Texas than General John Bankhead Magruder. The Southern decision makers heard him out but would not change their minds.

Chambers returned to Texas to find that Chambersia, his home at Anahuac, had been seized for nonpayment of debt and his young wife, thirty years his junior, and their two children evicted. Unable to reclaim his residence through the courts, Chambers waited until the occupant was gone and staked his rightful claim to the property by simply walking through the front door. Later that day, Chambers heard someone calling for him to come outside. It was the "thief," named McDonald, and a friend, and both men were armed.

"Suspecting treachery he (Chambers) loaded his gun, a double-barreled one, one barrel a rifle and the other a shotgun. With his foot against the door he carefully opened it and there stood McDonald and his companion with cocked guns. As Chambers stepped out, they raised their guns, but he was too quick for them. He killed McDonald with one barrel and desperately wounded the other man with the second barrel."

The slaying was ruled self-defense, and the victor moved back into Chambersia with his family.

An anonymous assassin put an end to Thomas Jefferson Chambers's controversial life on the night of March 15, 1865. He was shot to death while

This 1955 photo shows the home in Anahuac where Thomas Jefferson Chambers was slain by an anonymous assassin. Houston Chronicle *VF, Houston Public Library, HMRC.*

playing with his six-month-old granddaughter in the parlor of his Anahuac home. In spite of an abundance of suspects, including many neighbors as well as the man who bought Chambersia from his widow, the identity of the killer was never determined.

# 1
# HARLEY SADLER

## *The Tent Showman*

arley Sadler (1892–1954), a household name throughout West Texas, made his last personal appearance at a benefit for the Boy Scouts on October 9, 1954, but this time there would be no curtain call for the much-loved king of the tent shows.

Although a native of Arkansas, Harley came to Texas as soon as he could. The rest of his growing up was done on a farm near the Hopkins County hamlet of Cumby.

The lad learned two important things early in life. First, that the backbreaking toil and dawn-to-dark workday of the family farmer was not for him. Second, in his own words years later, "I have had from my earliest childhood an unexplainable desire to get into show business."

So, in 1909, the stagestruck seventeen-year-old ran away from home and joined a carnival. He discovered almost at once that he had been recruited under false pretenses—there was no band, much less an opening for a trombone player—but he stubbornly refused to go home.

The strong-willed youth survived by selling popcorn and cotton candy until his next brainstorm. He sweet-talked a pair of classmates into forming a traveling troupe, and the trio headed for Kansas City to take vaudeville by storm. But a double dose of homesickness broke up the act, leaving Harley all alone.

Finding a job as a bill poster, he worked his way to the Pacific coast and back, plastering multicolored advertisements on everything that stood still. Taking sick upon returning to Kansas City, he was forced to swallow his pride

and write his relatives for help. Harley's oldest brother fetched the prodigal son and escorted him by train to the Sadlers' new home in Stamford. During Harley's absence, his father had sold the farm, moved the family halfway across the Lone Star State and bought a general store.

Harley promised his worried mother, who nursed him back to health, that he would settle down and make something of himself. He meant every word, at least at the time, and went back to school. But his heart was not in it. The next year, he left for good.

Harley spent six months in Texas City with Rentfrow's Jolly Pathfinders, the top traveling tent show in the country. He knocked around as an apprentice comedian before landing an extended engagement at the Alamo Theater in Waco with a "tabloid company" that featured dancing girls, comics, singers and variety acts. Then, in late 1914, he was hired as a permanent performer by Roy E. Fox's Popular Players, an established repertoire company headquartered in Sulphur Springs.

Harley had moved up to first comedian with Fox in 1917 when he met a pretty young woman named Billie Massengale. In her role as city clerk of Cameron, she issued Harley the necessary permit for the itinerant tent show. Later that day, he asked her for a date on a note written inside a gum wrapper.

The couple must have really hit it off, because the next time Harley came through Cameron, Billie eloped with him out her bedroom window in the middle of the night. By the time Billie's father, who happened to be town marshal, caught up with them, they were legally husband and wife courtesy of an obliging justice of the peace.

Harley wound up not only winning over his in-laws but also putting them to work after going into business for himself. Harry Sadler's Own Show was a family affair of the first order, with Billie the leading lady and business manager, her mother the backstage director, her brother the head canvas man, his brother Ferd the advance man and Ferd's wife in the box office. Gloria, the Sadlers' daughter and only child, joined the company as soon as she could walk onstage.

Touring tent shows in the 1920s were, according to an entertainment expert for the *New York Times*, "a more extensive business than Broadway and all the rest of legitimate theater industry put together." Tent dramas were presented in sixteen thousand communities annually, compared to three hundred cities with Broadway-style productions.

People knew when to expect Harley—year after year, he followed the same route. Starting around Waco and Brownwood, the greasepaint gypsies

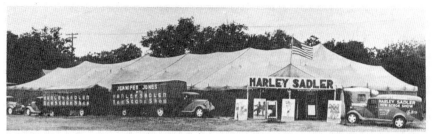

*Sadler's trucks proclaimed top billing for Jennifer Jones at the time the above picture was made, during the late 1930's.*

Harley Sadler's tent show was bleeding money when this picture was snapped during the depths of the Depression. Texas Star *VF, Houston Public Library, HMRC.*

took a northwesterly course through small towns like Monahans, Odessa and Kermit. After playing El Paso, the only big city on the itinerary, the troupe turned north into New Mexico for stops at Carlsbad, Hobbs, Clovis and Roswell before their Texas Panhandle pilgrimage. The season ended with a Christmas banquet in San Angelo, where the gigantic tent and paraphernalia were put into storage.

The program consisted of a three- or four-act play, a "rag oprie" with plot and characters drawn from the everyday experiences of the rural audience and vaudeville at each intermission. Specialty acts like trained dogs were an occasional treat, but cast members usually filled in as jugglers, magicians, ventriloquists, musicians and singers.

Harley was a stickler for clean, wholesome entertainment. "I don't believe the people out here care for bedroom farces and sex plays," he told a skeptical reporter, "and they do like a play that has a moral theme running through it."

He carefully screened new acts for objectionable material. "But Harley!" a first-time offender protested. "That line gets my biggest laugh in Dallas!" "This ain't Dallas," snorted the censor. "This is the country, and out here such things just don't go!"

Harley's folksy personality and amazing ability to remember everybody's name made him the most popular man in West Texas. He was a soft touch for any hard-luck story and never hesitated to loan his last dollar.

As the Great Depression tightened its hold on the economy in the early 1930s, Harley thought the solution was to spend more money. He bought a brand-new tent big enough for twenty-five hundred spectators and added more employees to the payroll. But west Texans, who did not know where their next meal was coming from, could not afford the price of a ticket.

By 1940, Harley was drowning in debt. Too hardheaded to declare bankruptcy, he sold off his equipment to pay the most persistent creditors and pleaded with the rest for a little time. With the meager profit from a scaled-down show in The Valley, he made good on his promise within two years.

After their daughter died giving birth in 1941, the Sadlers lost all interest in tent shows, which were fast becoming a thing of the past thanks to radio and air-conditioned movie theaters. Harley turned to oil and politics. He drilled a lot of dry holes but struck it rich with voters in the Sweetwater area, who elected him to three terms in the Texas House of Representatives.

As a legislator, Harley proved to be too good for his own good. "There has never been a milder, more sincere sort of man in the legislature than Harley

Harley Sadler (*far left*) and his wife, Billie (*center*), onstage in late 1940s. Texas Star *VF, Houston Public Library, HMRC.*

Sadler within the memory of the old-timers of the press corps," a political reporter for the *Austin American* observed.

Harley's more enthusiastic supporters wanted him to run for a seat in Congress or even governor of Texas, but he wisely decline. He did agree to step up to a seat in the state senate and was elected without opposition in 1952.

Two years later, Harley Sadler emceed a fundraiser in Avoca for the Boy Scouts. Stricken on the stage with a heart attack, he died the next morning in the hospital at Stamford.

Still mourning the tragic death of their daughter thirteen years earlier, Billie Sadler was inconsolable in her grief over Harley's sudden passing. Deciding there was nothing left to live for, she committed suicide the next year.

# 8

# LOUIS TREZEVANT WIGFALL

## *A Thorn in Everybody's Side*

With his inheritance squandered and his reputation in ruins, Louis Trezevant Wigfall (1816–1874) left his native South Carolina in the summer of 1846 to start a new life in Texas.

The son of wealthy planter parents, Wigfall spent his undergraduate days at South Carolina College, forerunner of the University of South Carolina. This period spawned in him a fanatical belief in state supremacy. His alma mater was a hotbed of secessionist sentiment; as early as 1827, the college president called for the Palmetto State to sever all ties with the United States.

Even though several friends and his own brother had died in the pernicious pastime of dueling, Wigfall was eager to take his turn on the "field of honor." When the chance finally came, he went on a bloody rampage. During five violent months, he engaged in a fistfight, two duels and a blazing gun battle on the steps of the local courthouse. One young man was killed in the wild spree and two were seriously wounded, including Wigfall himself, who was shot through both thighs.

Besides ruining his good name and law practice, the mayhem also burdened Wigfall's conscience, which tormented him for years with nightmare visions of the youth he had slain. Snubbed by polite society, hounded by creditors and overwhelmed with guilt, he migrated to Texas the year after annexation.

To his horror, the ghost of Thomas Bird, the dead duelist, followed Wigfall to the Lone Star State, or so he claimed in confidential conversations. Those who knew him best blamed the stubborn and well-traveled spirit for his drinking problem.

Getting in on the ground floor of the recently formed Democratic Party, Wigfall rocked the 1848 state convention with an inflammatory appeal to Southern patriotism. When the meeting adjourned, the thirty-two-year-old demagogue was firmly established as the most rabid states' rights advocate in Texas.

Wigfall's ball really began to roll two years later with an appointment to a vacancy in the Austin assembly. Sensing a favorable shift in the political wind, he exploited the unpopularity of Senator Sam Houston's pro-Union pronouncements by attacking his "laxity in defending Texas's interests." Never at a loss for words, Houston called his latest critic "the murderer Wiggletail" and "the drunken blatherskite from South Carolina."

Slave owners applauded the 1857 decision by the U.S. Supreme Court in the Dred Scott case, which upheld their right to do as they pleased with their human property. The dogmatic Texan, however, disagreed. To accept the justices' ruling, lectured Wigfall, was to acknowledge the power of the national judiciary over state sovereignty, a concession he was unwilling to make.

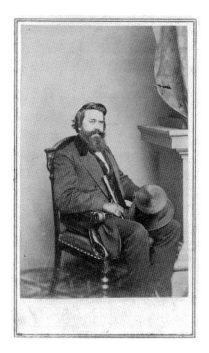

Secessionist firebrand Louis T. Wigfall served in both the U.S. and Confederate Senates. *DeGolyer Library, Southern Methodist University, Lawrence T. Jones Texas Photographs.*

While no one could hold a candle to Houston when it came to public speaking, most Texans agreed that the eloquent firebrand was a close second. During the gubernatorial campaign of 1857, Wigfall followed the candidate from town to town and gave his own rebuttal after every one of Houston's stump speeches. Wigfall took the lion's share of the credit for Hardin Runnels's upset victory in the only election Houston ever lost.

Three days after John Brown was hanged for treason in December 1859, Texas lawmakers picked a new U.S. senator. In the angry aftermath of the Harpers Ferry raid, their nearly unanimous choice was the arch-secessionist from South Carolina.

Upon hearing of Wigfall's election, Houston reportedly remarked, "Thank

God this country is great and strong that it can bear even that." He later added on a philosophical note, "I should think more of the fellow than I do, if it was not that I regard him as a little demented either from hard drink or the troubles of a bad conscience."

As a U.S. senator, Wigfall delighted in taunting his Yankee colleagues and tongue-lashed them black and blue. Secession was a simple matter, he told them. "If this government does not suit us, we will leave it." The South would not be cowed by Northern threats. "If we do not get into Boston before you get into Texas," he boasted, "you may shoot me."

The election in November 1860 of a minority president, the preference of only two out of five voters, set the stage for Dixie's departure. At a conference the next month of thirty congressmen from nine Southern states, Wigfall presented the case for secession in a paper, the "Southern Manifesto." He contended that Lincoln and the Republicans "are resolute in the purpose to grant nothing that will or ought to satisfy the South"; therefore, "the honor, safety and independence of Southern people required the organization of a Southern Confederacy."

Meanwhile, Wigfall's name cropped up in rumors of a bizarre plot to kidnap the lame duck in the White House. With James Buchanan out of the way, Vice President John Breckenridge of Kentucky would advance to the presidency, which he then would refuse to relinquish to Abraham Lincoln. But Breckenridge lost his nerve, and the conspiracy fizzled.

When informed of Texas's formal withdrawal from the Union, an exhilarated Wigfall gloated on the Senate floor, "We have dissolved the Union! Mend it if you can! Cement it with blood!"

He hung around the enemy capital for four more months, gathering intelligence for the Rebels, assisting in the purchase of arms for the future Confederate army and recruiting troops in Baltimore. He was present in April 1861 for the bombardment of Fort Sumter, where he personally dictated the terms of surrender to the outgunned Federal commander. In July 1861, the Republicans mustered the required votes to expel him from the Senate.

The Lone Star legislature elected Louis T. Wigfall to the Confederate Senate on November 4, 1861. No one, however, counted on the fire-eater raising as much hell in Richmond as he had in Washington. As a Texas member of the secessionist senate, Wigfall was at first a staunch supporter of President Jefferson Davis. But his wife hated Mrs. Davis, and her spiteful subversion on the home front poisoned the important relationship.

A bad situation took a turn for the worse when Wigfall gave his drunken imitation of the Union general Ulysses S. Grant. Wartime alcoholism

impaired Wigfall's judgment and ignited explosive rages. He blamed every Southern setback on Davis and expressed a warped wish to see him hang.

After the curtain dropped at Appomattox, Wigfall hid for months in the backstreets of Galveston before slipping aboard a British ship and sailing away to sanctuary. The exile returned eight years later but was so sick from years of chronic drinking that he had to be carried to a boardinghouse.

Louis T. Wigfall never got out of bed, dying alone in a rented room on February 18, 1874. The hottest of the red-hot Rebs had finally burned out.

9

# BOYCE HOUSE

## *King of the Texas Brag*

April 6, 1951, was "Boyce House Day" in Ranger, with folks coming from miles around to thank the guest of honor for writing the book "Roaring Ranger" that put the reformed boomtown in the national spotlight.

Boyce House (1896–1961) was born not in the Lone Star State but at Piggott in the northeastern corner of Arkansas. Noah House, a printer by trade, was editor of the local weekly when his wife gave birth to a baby boy in 1896.

Despite his Arkansas roots, House did much of his growing up in Texas. He went to school in Brownwood, Uvalde, Alpine and Taylor before his widowed mother announced they were moving to Memphis, just a short boat ride down the Mississippi River from his birthplace.

House lived in Tennessee's largest city long enough to finish high school and find his first job as a cub reporter with the *Commercial-Appeal*. For a young man in his early twenties, however, he was sick a lot, a situation easily remedied by returning to Texas in 1920.

His choice of Eastland County not only improved House's health but put him in the right place at the right time for two once-in-a-career news stories.

The newspaperman witnessed the infamous Santa Claus Bank Robbery in Cisco on December 23, 1927. He watched a local no-good dressed as Saint Nick and three accomplices hold up the First National Bank and, on their way out of town, shoot to death two lawmen. In his riveting firsthand account, which was picked up by the wire services, House called it "the most spectacular crime in the history of the Southwest surpassing any in which

Billy the Kid or the James boys had ever figured." He provided an exciting play-by-play of the largest manhunt to date in Texas history, which resulted in the capture and incarceration of the culprits.

On a lighter note, House was present two months later for the coming-out party of "Old Rip," a horned toad that supposedly survived three decades in the cornerstone of the Eastland County courthouse. He gave this offbeat tale the tongue-in-cheek treatment it deserved and, in the process, turned Old Rip into a celebrity and a tourist attraction.

In the 1930s, the full-time journalist moonlighted as an oil-boom historian. His books and steady stream of articles on the post–World War I discoveries in and around Eastland County led to the role of technical advisor for the 1940 motion picture *Boom Town* starring Clark Gable, Spencer Tracy, Claudette Colbert and Hedy Lamarr, the Austrian actress married for a short time to Houston oil tycoon Howard Lee. To learn everything there was to know about the boom days in Wichita Falls and Burkburnett, he wrote letters to hundreds of inhabitants in the two towns, asking them to share their personal experiences.

Resisting a rumored temptation to remain in Hollywood, House came home and reinvented himself. He combined his natural sense of humor with a love of the Lone Star past to become "King of the Texas Brag." *I Give You Texas: 500 Jokes of the Lone Star State* (1943) got his new career off to a Roman-candle start. Bookstores could not keep it in stock; Texans bought copies by the bushel to send to friends and family members serving in the military overseas. Total sales of *I Give You Texas* were said to have surpassed 200,000.

House followed this best seller with *Tall Talk from Texas* (1944) and *Texas, Proud and Loud* (1945). While those two books did not sell quite as well as his initial effort, demand was high enough to necessitate several printings.

Busy as he was during and right after the war, Boyce House found time to campaign twice for lieutenant governor. He had always taken more than a passing interest in politics and in his younger days corresponded extensively with his hero, William Jennings Bryan, prior to the death of "The Great Commoner" in 1925. In 1942, the old-time populist finished a respectable third in a field of nine candidates in the Democratic Party primary.

Four years later, he sought the same office and gave Allan Shivers all he could handle. House's surprisingly strong showing in the first round of voting forced a runoff, which the future three-term governor won, but only by pulling out all the stops.

Boyce House (*right*) wrote best-selling books, magazine articles and a weekly column carried by 130 Texas newspapers. *RGD5F0111-01, Houston Public Library, HMRC.*

If House had bested Shivers in the head-to-head contest and won reelection in 1948, he would have been sworn in as the governor of Texas when Beauford Jester died of a heart attack on July 11, 1949.

Having scratched his political itch, House began writing a weekly column that eventually appeared in 130 newspapers. To his busy schedule, he soon added his own regular radio show.

For a time, House rivaled J. Frank Dobie for the honorary title of "Mr. Texas," but Dobie had nothing but high praise for the humorist he considered "a poet as well as historian and wordwielder."

*Roaring Ranger: The World's Biggest Boom* was House's 1951 sequel to *Were You in Ranger?*, published sixteen years earlier. After reading both hard-to-find classics for my recent book *Texas Boomtowns: A History of Blood and Oil*, I understand why the residents of Ranger were so keen on expressing their appreciation by throwing a daylong party for the author.

He showed them at their best and, when necessary, their worst under the difficult and often downright dangerous conditions of the typical

Texas oil boom. Yet he never "turned against" them, no matter their shortcomings—much like Bryan, whose three failed bids for the White House did not cause him to lose faith in the common people.

House's seventeenth and final book, a collection of amusing anecdotes from his many years in the newspaper business, came out in 1957. Although he stayed active as executive vice president of a consumer finance association, the writing well evidently had gone dry.

House suffered a major heart attack in September 1961 from which he never truly recovered. On the morning of December 30, 1961, he bought a paper as usual in the lobby of the Fort Worth hotel where he lived and went back upstairs to read it. A little before noon, the maid found him dead in bed.

During his long reign as "King of the Texas Brag," Boyce House delighted in disarming out-of-state critics with his distinctive brand of humor. "Texans at heart are really modest," he once wrote. "But when we tell the plain, unadorned, unretouched truth about our incomparable state, we are accused of exaggerating."

# HARPER BAYLOR LEE

## The Gringo Matador

**H**arper Baylor Lee (1884–1941), the first and finest matador from north of the border, made his big-time bullring debut in Mexico City on May 16, 1909.

Born James Harper Gillett at Yseleta, the oldest town in Texas long since gobbled up by El Paso, he came with a sterling Lone Star pedigree. His father was Texas Ranger James B. Gillett, and his mother was the daughter of Colonel George W. Baylor, the scourge of the West Texas tribes.

Gillett is best known for *Six Years with the Texas Rangers*, a book-length account of the bloody climax of the Indian wars, which he witnessed firsthand as a member of the Frontier Battalion. He served under Colonel Baylor, the most bloodthirsty Indian fighter on the western frontier—Baylor once asked a governor if he had any redskins he wanted scalped. Walter Prescott Webb, the acknowledged authority on the Rangers, praised Baylor's "courage and zeal" but added that he "lacked reserve, was a poor disciplinarian, and an indifferent judge of men."

James Gillett married his commander's teenage daughter Helen in 1881, the same year he left the Rangers. He did, however, stick to law enforcement—the only thing he knew. The long hours and disreputable associates led to his unhappy wife filing for divorce in 1888.

Helen took her son and went to live with her parents. Four years later, she found true love once more, again with a Texas Ranger, but this union did not last long enough for the couple to celebrate their first anniversary. Husband number two was murdered by horse thieves in a Rio Grande ambush.

Even with a twelve-year-old boy in tow, the attractive widow had her pick of suitors. The winner of the husband lottery was the manager of an El Paso hotel named Samuel Lee. He popped the question, Helen answered in the affirmative and they tied the knot in 1895. Then it was off to Guadalajara, Mexico, where the groom had a new job as a construction superintendent.

Helen sent for her son a few months later. To his worried mother's relief, he had no trouble adjusting to the foreign way of life, especially the bullfight.

At school, the young Texan changed his name to Harper Baylor Lee, adopting the surname of his stepfather, whom he much admired. But in 1903, his world was suddenly turned upside down by the death of the one person he had always been able to count on—his mother.

Fortunately, Lee was eighteen years old at the time of her passing and ready to take on the world. He already had participated in dozens of amateur corridas, or bullfights, dispatching eight bulls. His natural talent caught the eye of a retired matador called El Chiclanero, who gradually took the gifted gringo under his expert wing.

Nevertheless, Lee did not consider Mexico's national pastime anything more than an exciting lark until the day he received a special invitation to a charity corrida. The gala brought out the best in him, and Lee's impressive performance earned the personal recognition of the governor, who urged him to turn professional.

Encouraged as well as flattered by the attention, Lee eagerly took the politician's advice. Another factor in the momentous decision, though possibly in the back of his mind at the time, was the familiar taunt that no gringo had the guts to become a true matador.

In his first year on the professional circuit, fights were hard to come by. Lee appeared in just six events and only in backcountry rings against third-rate toros. Undeterred, he vowed to make it to the big time in Mexico City.

Then overnight, the novelty of an American matador transformed the struggling rookie into a star attraction; in a matter of weeks he was flooded with offers. Lee's wish came true in May 1909 with a booking for the Plaza de Toros El Toreo, the pride of the capital and the top bullring in the entire country.

Fate dealt the twenty-four-year-old an unnerving hand that historic afternoon, when it was announced that the scheduled bulls included the fierce Miuras, a Spanish breed rarely seen in the western hemisphere. Miuras had recently gored six Spaniards in a single day, a bloodbath that inspired a campaign to ban the breed.

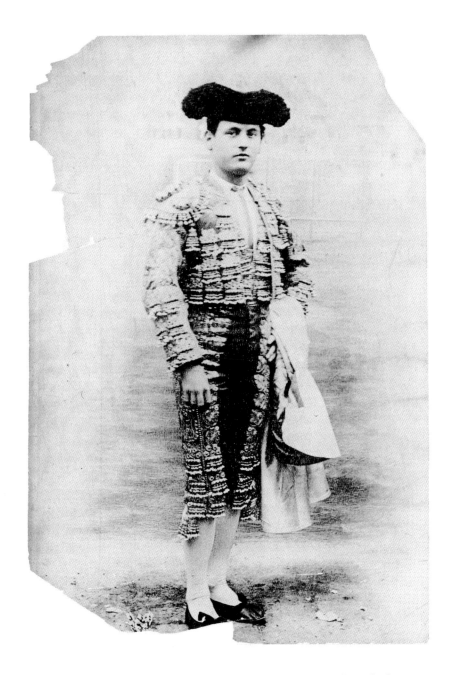

Harper Baylor Lee looked the part in his matador costume. *DeGolyer Library, Southern Methodist University, Elmer and Diane Powell Collection on Mexico and the Mexican Revolution.*

When Lee stepped onto the sand, skeptical spectators gave him a cool reception. In spite of his traditional costume, there was no mistaking the tall Texan with his wavy auburn hair and light complexion for a homegrown bullfighter. He had "Born in the USA" written all over him.

But even before his first kill, the handsome American had the crowd eating out of his hand. When the snorting Miura entered the ring, a hushed anticipation filled the air. After a death-defying ballet, Lee went right over the horns and with a single thrust of his sword dropped the beast in its tracks.

Lee was the toast of Mexico City and the hottest item in the U.S. press. With readers demanding the lowdown on their exotic countryman, fast-thinking newspaper editors concocted a fascinating but utterly fictitious biography.

In most of the articles, Lee was a native not of Texas but upstate New York. To give the story an Ivy League touch, he was reported to be a graduate of Harvard—a bizarre twist, since Lee had never set foot on a college campus. When the fanciful accounts of his obscure existence reached the overnight sensation, he merely laughed along with his companions.

Bullfighting was no laughing matter, though, as Lee soon discovered. A crowd-pleasing daredevil at heart, he took more chances than usual in order to live up to the star billing that came from his Mexico City exploits. The result was a horn in the thigh the very next month.

During the two and a half years that followed, Lee fought thirty-three times and registered seventy-one kills for a grand total of one hundred. But he was seriously gored on three occasions, the last in his final corrida in the fall of 1911.

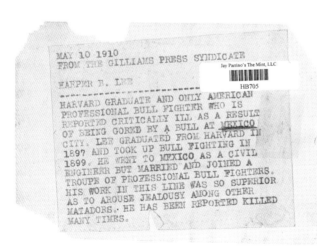

A 1910 wire service description of the gringo bullfighter was more fiction than fact. *DeGolyer Library, Southern Methodist University, Elmer and Diane Powell Collection on Mexico and the Mexican Revolution.*

Even though the wound required surgery, Lee believed he would bounce back like always after a brief recuperation. But blood poisoning set in and turned his recovery into a long and incredibly painful ordeal.

At the age of twenty-seven, Lee hung up his cape and eventually returned to Texas with his wife. He had been back in the state and country of his birth for two years when old Colonel Baylor talked him into a reunion with the father he had not seen in nearly two decades. The carefully planned meeting in a San Antonio hotel led to Lee accepting Gillett's offer to work on his far West Texas cattle ranch in exchange for part ownership of the spread once he retired.

Lee was so thrilled by the handshake agreement that he changed his name one last time, to Harper B. Gillett. He and his wife put in their time at the Gillett ranch but, after three years, had only a few head of cattle to show for it. Convinced his father had no intention of living up to his end of the bargain, he sold his small herd to his half brother and bought a chicken farm near San Antonio.

That was where Harper Baylor Lee took his last breath in 1941. All things considered, it was a peaceful passing the first-of-his-kind matador likely would have been denied had he kept on fighting the bulls.

# ⅠⅠ
# HUBERT KNICKERBOCKER

## *Warned the World About Hitler*

For years, award-winning journalist Hubert Renfro Knickerbocker (1898–1949) implored the public to take a hard second look at Adolf Hitler and the threat fascism posed to democracy and world peace. But he was drowned out by Charles Lindbergh, the greatest American hero of the twentieth century, who insisted that events in Europe did not concern this country.

Knickerbocker was a native of Yoakum and a graduate of Southwest University in Georgetown. A short tour of duty in the army along the Mexican border and a job in Austin delivering milk preceded his 1919 departure for New York City.

Although "Red" (the natural nickname for someone with a full head of crimson hair) planned on a career in psychiatry, between classes at Columbia he moonlighted as a cub reporter for two Manhattan newspapers. Returning to Texas in 1922, he chaired the journalism department at Southern Methodist University for a term before leaving for Germany to continue his studies.

Knickerbocker had no sooner arrived in Munich than he witnessed firsthand the Nazi Beer Hall Putsch of November 1923. After selling his top-notch report of the crushed coup that landed a charismatic rabble-rouser named Adolf Hitler in prison, the young Texan decided that the newspaper business was for him, instead of the more lucrative mind game.

He moved to Berlin and by 1928 was the chief correspondent for the *New York Evening Post* and the *Philadelphia Public Ledger*, positions he held for the

thirteen most eventful years of the twentieth century. Mastering the unfamiliar foreign language, he wrote two regular columns and six books, all in perfect German.

Friends, possibly with tongues in cheeks, told the story of how Knickerbocker succeeded in replacing Dorothy Thompson, once rated the second-most-important woman in America behind First Lady Eleanor Roosevelt, as Berlin bureau chief. They claimed the thirty-year-old upstart introduced Thompson to the novelist Sinclair Lewis and pulled the romantic strings that resulted in their marriage.

Hubert "Red" Knickerbocker, foreign correspondent and one-man lobby for U.S. intervention in World War II. *RGD5F4519-03, Houston Public Library, HMRC.*

A 1931 Pulitzer Prize did not protect Knickerbocker from the wrath of the Nazis after they took power two years later. Promptly deported for his critical coverage of the fascist regime, he interviewed dozens of important Europeans for his 1934 best seller *Will War Come to Europe?* The book accurately predicted World War II.

Meanwhile, most Americans were doing their dead-level best to ignore the alarming developments on the distant continent. Reinforcing this head-in-the-sand isolationism was none other than pioneer aviator Charles Lindbergh. On four occasions between 1936 and 1938, the "Lone Eagle" visited the Third Reich and each time came back with a positive opinion of the Nazis. "Don't believe anything you read about them in the press," he said. "It's lies. All lies."

Even as the German blitzkrieg rolled through Poland in September 1939, Lindbergh went on nationwide radio to argue more strongly than ever for neutrality. Urging millions of listeners to be "as impersonal as the surgeon with his knife," "Lucky Lindy" advised fellow Americans "not to permit our sentiment, our pity or our personal feelings of sympathy to obscure the issue."

While the British endured incessant bombing by the Luftwaffe, a Gallup poll taken in April 1941 showed that 80 percent of the American people still opposed going to war. That same month, Knickerbocker addressed an Austin audience on a hectic speaking tour while Lindbergh enlisted in the largest noninterventionist lobby.

In the weeks following the recruitment of the influential figure, the membership of the America First Committee nearly tripled, to more than 800,000 people. The organization included the usual assortment of kooks and crackpots, but the vast majority was respectable citizens committed to keeping the United States out of another bloodbath in Europe.

Although President Franklin Roosevelt the previous year had confided to a key aide, "I am absolutely convinced that Lindbergh is a Nazi," he dared not openly attack the national hero. But after Lindy officially endorsed the America First Movement, FDR compared him to the Northern "copperheads" who sided with the South in the Civil War.

In the spring of 1940, Knickerbocker took time out from his globetrotting duties to refute the logic of Lindbergh and the America First lobby in a series of public lectures. More often than not, his pro-war presentation was not well received. Americans were in no mood to fight the Germans or anybody else; and besides, they put their trust in Lindbergh.

However, given enough rope, Lindbergh eventually engineered his own downfall. In a September 1941 speech, he expressed pity for the plight of the persecuted Jews in Europe. In the next breath, however, he warned American Jews of similar treatment if they insisted on pushing the nation into war.

The rash remark was roundly condemned by prominent individuals from all walks of life. With a thundering crash, Charles Lindbergh fell off his unique pedestal. His priceless reputation was in pieces. America's love affair with the conqueror of the Atlantic was over.

Boldly taking the initiative, Knickerbocker went on another lecture tour. On the night of November 20, 1941, he spoke to a hostile crowd at the Dallas college where he had taught less than two decades earlier. After his talk, he exchanged heated remarks with SMU students who had shown up to heckle him.

Knickerbocker had the last word with this stinging rebuttal: "You had your counterparts in the University of Paris, in the University of Prague, in the Hague. And those universities don't exist anymore. The Gestapo has taken over the education of young men."

The debate abruptly ended two weeks later on December 7, 1941. Japan's unprovoked attack on Pearl Harbor made the issue of nonintervention a moot question.

Knickerbocker derived no personal satisfaction from Lindbergh's disgrace or the fact that it took an act of Japanese aggression to bring Americans to their senses. He would have much preferred to have been wrong and witness world peace than to be right and see world war.

Knickerbocker was one of the busiest, bravest and most respected foreign correspondents of World War II. When the cataclysmic conflict was finally over, he came back to the States and took a job with a Newark, New Jersey radio station to be close to his wife and four children.

But in July 1949, restless "Red" could not resist a journalist junket to the Far East with a dozen other newspapermen, most of them old associates from the war years. Tragically, their commercial airplane went down near Bombay, India, killing all aboard.

Homage was paid to Hubert Knickerbocker in newspapers big and small throughout the country.

*We at International News Service all knew Knickerbocker well. His job was more or less that of roving correspondent. He was known in Vladivostock and London, in Berlin and in Moscow, in Paris, Rome, Cairo and Athens—even in Addis Ababa for one of his first big assignments was to cover the Ethiopian war.*

*There was much that was fantastic in the lifetime of this quiet, soft-spoken man of fifty-one who never lost his Texas drawl. He probably was one of the few persons in existence who spoke a half dozen languages with a Southern accent.*

Knickerbocker's father, a retired Methodist minister, was at his home in Dallas when he was informed of the tragedy by telephone. "My son was at the top professionally, morally and intellectually," the former preacher told the *Morning News* with unmistakable pride. "If he had to go, it's good he went at the pinnacle of his success."

The reporter on the other end of the line asked the standard question: Was his boy afraid to die?

The elder Knickerbocker answered with an emphatic "No." "He has covered five wars and has been exposed to death a thousand times. Death was no stranger to my son. He knew death well."

# DAVID GOUVERNEUR BURNET

*"Born to Be Unpopular"*

avid Gouverneur Burnet (1788–1870), the first president of Texas, was born in Newark, New Jersey, into a family with a tradition of distinguished public service. His father served in the Continental Congress, a brother served in the U.S. Senate and another brother was elected mayor of Cincinnati, Ohio.

At seventeen, David Burnet sacrificed a modest inheritance in a noble but futile attempt to keep his employer's sinking company afloat. Poor business judgment turned out to be a lifelong curse that kept him on the brink of poverty.

Carried away by an idealistic impulse to save the world, Burnet joined a crusade to liberate Venezuela. Most of those Quixotes not chopped to pieces by the Spaniards succumbed to yellow fever. The lucky American was among the fortunate few who made it out of the South American country alive.

Leaving the peasants of Venezuela to free themselves, he opened a trading post in Louisiana. The enterprise failed, and so did his health. Wracked by tuberculosis, he chose not to lie down and die but instead to take a solitary one-way ride into the wilderness of Texas.

Puzzled Comanches found the delirious white stranger on the banks of the Colorado River. In an act of kindness out of character for the fierce warriors, they took pity on Burnet and nursed him back to health. He lived with the band for two years and gradually regained his health.

Years later, a biographer recorded his amazing experience: "He slept without shelter through the vicissitudes of the seasons, and subsisted

entirely on wild game. The food, exercise and climate of that delightful and invigorating region repaired the wastes of disease, renewed his physical energies and restored him to vigorous health."

Burnet spent five years in Cincinnati before coming back to Texas in 1826 and putting down permanent roots. He obtained a potentially lucrative empressario contract complete with a land grant for the settlement of Anglo-American immigrants. However, he again allowed a golden opportunity to slip through his fingers, showing once more that he did not have a head for business.

Jumping feet first into provincial politics, Burnet made a major splash in 1833 by authoring the Texans' petition for a separate spot under the

Living With Comanche Indians

Independence House

—Text by Jim Mathis, Drawings by Bud Bentley

David G. Burnet could have been a stand-in for an angry Old Testament prophet. *Houston Post, May 14, 1961, Houston Public Library, HMRC.*

Mexican sun. As the colonists clamored for the expansion of their limited rights, he rose to prominence.

The historic convention at Washington-on-the-Brazos picked Burnet to be the interim president of independent Texas on March 26, 1836. But the duties of the new office quickly took a back seat to the more urgent necessity of evading Santa Anna.

In spite of his frantic flight, Burnet found time to bombard his commander in chief with caustic communiqués. "The enemy are laughing you to scorn," he informed Sam Houston. "You must fight them. You must retreat no farther. The country expects you to fight."

Burnet was stranded on Galveston Island wondering where next to run when word reached him of the miracle at San Jacinto. Nevertheless, the victorious general received less than rave reviews from his envious president.

In a show of gratitude, Houston distributed $12,000 in captured silver to the unpaid soldiers, who had whipped the Mexican army. Burnet furiously insisted the spoils of war should be given to the destitute government. In petty retaliation, the president refused passage on a Galveston-bound ship to the wounded general. Ignoring Burnet's spiteful order, Thomas Rusk helped to carry the hero aboard.

Burnet continued to serve as caretaker chief executive until Texans elected his replacement that September and Houston took office six weeks later. Arguably Burnet's most important accomplishment during a difficult summer was keeping the captive Santa Anna out of the hands of lynch mobs that wanted to string him up.

"Born to be unpopular" was how one historian bluntly described Burnet. His stuffy and pretentious manner and know-it-all attitude rubbed Texans the wrong way and left a negative impression he found virtually impossible to overcome.

But it was Burnet's runaway ego that grounded his sky-high ambition. Hatred of Houston festered into a fanatical obsession that drove him to self-destructive extremes.

As vice president of the Lone Star republic, he hoped to succeed his close friend and ally, Mirabeau Lamar, and finally get the best of Houston in the election of 1841. The campaign set a new low for mudslinging, with Burnet calling his hard-drinking opponent "Big Drunk" and Houston responding with "wetumpka" (Cherokee for "hog thief") and "Little Davey," a reference to the candidate's short stature. When it was all said and done, Sam had won a second presidential term by a whopping three-to-one margin.

Five years later, Burnet blamed his nemesis for sabotaging an appointment to the federal bench. In reality, he received scant support for the prestigious post because of his lackluster judicial record.

Even their mutual opposition to Southern secession failed to bring the old warhorses together. By the time the Confederacy collapsed, Burnet's entire family had perished.

Seventy-eight years old and dependent on the generosity of friends for his very survival, Burnet's day seemed to have dawned at last in 1866. Despite his well-known Unionist sympathies, the reconvened legislature chose him along with Oran Roberts to be Texas's first post–Civil War senators.

Burnet rated their chances in a Washington controlled by Radical Republicans as somewhere between slim and none, and he was right. The Radicals had other plans for Texas and the rest of the defeated South that did not include readmission to the Union and a place in the U.S. Senate.

Burnet spent Christmas 1866 in New Jersey with relatives he had not seen in decades. Soon after Americans rang in the New Year, the Radicals officially refused to seat him and Roberts. The two men returned to Texas.

With a flowing white beard and craggy face, David G. Burnet could have passed for an angry Old Testament prophet. On the eve of his death in 1870, the bitter and bewildered ex-president burned his private papers. In one fell swoop, he tried to erase the past and punish posterity.

# 13

# ADAH MENKEN

## *Civil War Sex Symbol*

A dah Menken (1835–1868), the original self-made celebrity, stepped onto the stage for the last time on May 30, 1868, in Paris, France.

While most historians and researchers concur that the "Naked Lady" came into this world in 1835, they cannot agree on where she was born, to whom or even her real name. That was Menken's fault—she deliberately sowed confusion concerning her roots and early life. In 1865, she claimed that her true name was Dolores Adiso Los Fiertes and that her parents were a French woman from New Orleans and a Jewish Spaniard. Three years later, in "Some Notes of Her Life in Her Own Hand," published in the *New York Times*, she wrote that she was actually Marie Rachel Adelaide de Spenser, born in Bordeaux, France, spent her childhood in Cuba and moved to New Orleans with her family while in her teens.

The *Handbook of Texas*, the recognized authority on all things Texan, states that she was christened Ada C. McCord by humble parents in Memphis, Tennessee. The most popular opinion, at least for the present, is that she was Adah Bertha Theodore, daughter of a Creole mother and a free black father in New Orleans.

Wherever she came from, we know for a fact that in October 1855, Adah was in the Southeast Texas town of Liberty entertaining the inhabitants with readings from Shakespeare. It is also true that she published a few poems and essays in area publications before marrying Alexander Isaac Menken, a musician from Cincinnati, in an April 1856 ceremony at Livingston.

It should be noted that Menken may have been the second of Adah's many husbands, since some sources contend she married and divorced another musician shortly before meeting Menken. The next year, the newlywed made her theatrical debut in Shreveport in a play called *The Lady of Lyon*. Sometime later, while visiting her in-laws, she converted to their religion and remained a practicing Jew for the rest of her life.

By 1859, Adah was in New York, where she appeared in her first Broadway production. Critics, who are not paid to pull their punches, were less than kind. The *New York Times* reviewer branded her "the worst actress on Broadway," and another columnist wrote, "She is delightfully unhampered by the shackles of talent."

Back in Cincinnati, the Menkens hit the ceiling over their daughter-in-law's career choice. After all, no decent woman in the Victorian age made a spectacle of herself, and that was what actresses did for a living. They pressured their son into ending the marriage, which he was more than ready to do, since his wife had taken to smoking cigarettes and wearing pants in public.

Adah kept her ex-spouse's name and stayed in Manhattan to chase her dream. She met and soon married the Irish prizefighter Johnnie "The Benicia Boy" Heenan. While Adah may have loved hubby number two, she loved even more the limelight the popular bare-knuckle champion brought with him.

In early 1860, Heenan left Adah with child and no money when he went off to London to fight the English title-holder. While he was away, the story broke in the New York papers that the actress was not the boxer's lawfully wedded wife.

Estranged husband Menken declared that Adah never bothered to divorce him, an oversight that made her a bigamist. Heenan came home to a scandalous storm that threatened to tarnish his wholesome image. In a heartless act of self-preservation, the pugilist lied through his remaining teeth, insisting, "The woman calling herself my wife is an imposter."

Blacklisted on Broadway, Adah almost starved to death. To make her misery complete, her baby boy died shortly after birth.

It was at this low point in Adah's life that manager Jimmie Murdock landed her the leading role in *Mazeppa*, a play based on Lord Byron's poem about to open in Albany in June 1861. Not only would his client be the first woman to play the part, Murdock also had an ingenious plan to capitalize on the scandal she could not live down.

In the dramatic climax of *Mazeppa*, the hero is stripped, lashed to a wild horse and rides bareback across the stage. In previous versions, a dummy

Adah Menken
by
Gene Coughlin
American Weekly
Feb. 20, 1949

Alexandre
Dumas

Illustrated by MICHAEL

*Above*: The "Menken" receives French author Alexandre Dumas in her dressing room in this stylized drawing that exaggerated her beauty. American Weekly *VF, Houston Public Library, HMRC.*

*Left*: This more realistic view of Adah Menken reveals the actress as rather plain. Houston Chronicle *VF, Houston Public Library, HMRC.*

stood in for the live actor—but not this time. Adah took the thrilling ride in flesh-colored tights.

Overnight, Adah became the sensational "Naked Lady," the sex symbol of the Civil War. She fielded drooling reporters' questions in Mae West fashion while lounging on a tiger skin and sipping champagne. She always gave them provocative pearls of wisdom, such as, "Good women are rarely clever and clever women are rarely good."

After milking *Mazeppa* for all it was worth in New York, Adah took her show to the "City by the Bay," where the reception was even more enthusiastic and financially rewarding. Upper-crust New Yorkers had looked down their noses on her, but open-minded San Franciscans from every strata of society embraced "The Menken," as she was now known, as one of their own.

An aspiring young author destined to be an American institution attended a performance of *Mazeppa* for a local newspaper and his own amusement. "When I arrived in San Francisco," wrote Mark Twain, "I found there was no one in town—at least there was no one in town but 'The Menken'—or rather no one was being talked about except that manly young female."

"I went to see her play *Mazeppa*, of course," he went on. "She is a finely formed woman down to her knees; if she could be herself that far…she would pass for an unexceptional Venus. Here every tongue sings the praises of her matchless grace, her supple gestures, her charming attitudes. Well, possibly those tongues are right."

What Twain saw instead was a wild woman who "rushes onstage in the first set and carries on like a lunatic from the beginning of the act to the end of it. If this be grace, then Menken is eminently graceful."

Following her conquest of San Francisco, Adah went to London and Paris. She glided effortlessly through aristocratic and literary circles, collecting admirers and casual lovers like postage stamps. Stuffy Victorians were both scandalized and delighted by her wicked ways on and off the stage. The French learned a thing or two from the female libertine.

On her triumphant return to New York in April 1866, Adah commanded the highest salary ever paid to a performer of either sex. The actress who had been banned from Broadway never saw an empty seat at her sold-out shows, despite a cholera epidemic.

But Adah had burned the candle at both ends for far too long. She had run through a fortune and two more husbands and, worst of all, wrecked her health.

Catching a boat back to Europe in August 1866, Adah had to be carried to her stateroom. Faint hopes of a rejuvenating comeback quickly faded for yesterday's star.

Adah Menken was thirty-three years old the day she died in a cheap hotel in Paris. With eternity knocking at the door, she wrote: "I am lost to art and life. Yet have I not at my age tasted more of life than most women who lived to one hundred? It is fair then that I go where old people go."

14

# TOM HICKEY

*The Voice of Texas Socialism*

O beying a direct order from Washington, the postmaster at Hallettsville confiscated the latest edition of the *Rebel* on June 17, 1917.

What caused the suppression of Texas's leading socialist newspaper by the Woodrow Wilson administration? The official story was publisher Tom Hickey's (1869–1925) outspoken opposition to the president breaking his campaign promise to keep the nation out of the war in Europe. But some believed the *Rebel* had been living on borrowed time ever since "Red Tom" made public the Texas-born postmaster general's replacement of tenant farmers on his plantation with convict labor.

In 1860, nearly all farmers in Texas held title to the land they tilled. Half a century later, an estimated 53 percent were hired hands working the fields for absentee owners.

The landlord's customary cut in the late 1800s was a fourth of the cotton and a third of the other crops raised by his tenants. However, after the turn of the century, many began to require cash payments, an unreasonable demand that drove sharecroppers deeper into debt and turned them into modern-day serfs.

Although biased "experts" argued that hardworking renters could eventually escape the tenant trap, the sharecropper knew better, and so did the *Dallas Morning News*. "Nine out of ten of the tenants of today, probably nineteen out of twenty, are destined to remain tenants," the big-city daily admitted in 1910.

Hoping to steer dissatisfied sharecroppers toward the Socialist Party, organizer Thomas Aloysius Hickey created the Renters Union and a weekly

publication called the *Rebel*. Shunned by Democrats and Republicans alike, the outcasts eagerly embraced anybody who showed the slightest sympathy for their plight.

The Renters Union quickly blossomed into a mass movement with a radical instead of a reformist agenda. The seething resentment previously reserved for landowners escalated into a scathing indictment of the entire capitalist system.

In record time, the *Rebel* had twenty-two thousand subscribers, and *Appeal to Reason*, the national party organ, claimed a paid circulation of forty thousand in the Lone Star State. Inspired by Hickey's success, forty socialist papers popped up in places like Texarkana, Grand Saline, Palestine and Mount Pleasant.

At first, Hickey came under sharp criticism from his superiors for failing to advocate collectivized agriculture according to socialist dogma. The nasty letters from the national headquarters suddenly stopped in 1912, when the Texas branch of the Socialist Party emerged as the fastest-growing state organization in the country.

In that year's presidential election, Eugene V. Debs tripled his vote from 1908, receiving nearly 9 percent statewide and twice that in parts of East

Tom Hickey *(far left)* poses with fellow socialists or, more likely, investors in his oil ventures in the early 1920s. *Thomas Hickey Collection, SWC PC, 633 PC, Texas Tech.*

Texas. Impressed by "the true socialist spirit" of his supporters, Debs declared, "Many of them have scarcely a crop between themselves and destitution and yet they are the most generous, whole-hearted people on earth and for socialism would give the last of their scant possessions."

The radical influence extended even to Dallas, where the socialist candidate for mayor took a surprising third of the turnout. Despite the fact that no left-winger had ever won a single ballot box in Big D, he carried seven of the city's thirty-three precincts.

Intoxicated by these triumphs, Texas socialists expected an electoral breakthrough in 1914. But a shrewd banker from Temple with a down-home style stole their thunder and the bulk of their tenant farmer base.

Jim Ferguson roared through the countryside like a springtime tornado and carried off the spellbound sharecroppers. In the process, he singlehandedly blew the bewildered socialists off the political map.

Hickey and his associates tried to tell themselves that the truant tenants would return to the fold the moment the Democrat showed his true colors. But they misjudged the magnetic appeal of "Farmer Jim," who would command the allegiance of poor rural Texans for the next thirty years.

Meanwhile, the looming prospect of American involvement in the "Great War" was not popular with Texans of every political stripe. In a letter to Colonel Edward Mandell House, a fellow Texan and President Wilson's top advisor, a prominent Democrat reported "an overwhelming desire for peace, not perhaps at any price, but at most prices, which is altogether unprecedented in the history of this country."

The plot thickened in May 1915, when William Jennings Bryan resigned as secretary of state in protest of Wilson's tilt toward the Allies following the German sinking of the *Lusitania*. At autumn appearances in Dallas and Houston on a coast-to-coast speaking tour, the three-time candidate for the White House warned against the growing danger of militarism.

Wilson's November 15 announcement of a preparedness plan, widely interpreted as a prelude to U.S. participation in the war, galvanized his Texas critics. A coalition of clergy, farmers, prohibitionists and pacifists countered with a campaign against the military buildup.

Long an advocate of replacing the expensive standing army with a citizen militia, Oscar Callaway denounced the increase in defense spending as wasteful warmongering. The West Texas congressman from Comanche declared in January 1916, "Europe is on fire all right but there is about 3,000 miles between us and the conflagration."

A new crisis surfaced on February 15, 1916, when Wilson hinted that Germany would be held responsible for American lives lost in submarine attacks on Allied shipping. Two days later, Jeff: McLemore introduced in the House of Representatives his so-called warning resolution advising U.S. citizens to avoid vessels subject to sinking by the Germans.

The Austin magazine editor, who used a colon to abbreviate his middle name, emerged overnight as the symbolic spokesman of the nationwide movement to stop the steady slide toward war. Spurning appeals to party patriotism, McLemore insisted that the president was not above reproach merely because he was a Democrat.

Wilson mustered sufficient support to table the warning resolution in the House and a similar measure in the Senate. Nevertheless, half of the Lone Star delegation put their careers on the line by siding with their controversial colleague.

In addition to Oscar Callaway, praised by his hometown paper for an "absolute lack of fear of criticism," others who dared to break party discipline included James Harvey "Cyclone" Davis and James Luther Slayden. The former was a fiery populist recently readmitted to the Democratic fold; the latter was a past president of the American Peace Society and an eleven-term incumbent from San Antonio.

"He kept us out of war" was the cynical slogan of Woodrow Wilson's reelection campaign and the key to his narrow victory over the Republican Charles Evans Hughes in November 1916. McLemore and Slayden survived administration-sponsored challenges, but Calloway and Davis went down to defeat.

Five short months later, President Wilson dropped his "peace candidate" masquerade and asked Congress for a declaration of war against Germany. Jeff: McLemore stood his ground and sealed his fate by casting one of fifty "nay" votes in the House of Representatives. "I am not yet ready to vote absolutism to any president," explained the plainspoken politician, "nor will I ever vote to abrogate the Monroe Doctrine by forming any alliance with the warring nations of the Old World."

Slayden, on the other hand, decided to go along in order to maintain his "usefulness in Congress." The war, he rationalized, was "an accomplished fact." If Slayden thought his late conversion to Wilson's crusade to "make the world safe for democracy" would patch things up with the party hierarchy, he was sadly mistaken. An election eve statement from the White House questioning his loyalty to the president forced the congressman to abandon his bid for a twelfth term.

The Texas legislature removed the remaining thorn from Wilson's side by redistricting McLemore's at-large seat out of existence. No quitter, he entered a Gulf Coast Democratic primary but finished a poor third in his last bid for public office.

As for Tom Hickey and the dwindling number of Texas socialists, they had counted on another presidential campaign in 1916 by the charismatic Eugene Debs to get their movement back on track. But the aging agitator sat that election out, and his colorless stand-in attracted little interest and even fewer votes. When Debs next ran for president in 1920, it was from the federal penitentiary in Atlanta where he was serving a ten-year term for resistance to the war and conscription.

The inevitable crackdown on Texas radicals came in 1917, shortly after the United States entered the European conflict. Following his release from federal custody for anti-draft activities, "Red Tom" accused the government of using the war as an excuse "to crucify a political opponent they could not bribe or control."

Hickey expressed this opinion in hand-written letters because he no longer had a newspaper. The very first target of the Espionage Law had been none other than the *Rebel*, banned from the mail as a threat to national security.

Hickey's foreign birth and left-wing politics made him a target for deportation during the "Palmer Raids" carried out in 1920 by President Wilson's attorney general. Had he been Italian or Eastern European instead of Irish, there can be no doubt that he would have been forcibly returned to his country of origin as an "undesirable."

Tom Hickey remained a socialist until his dying day but dialed his activism down several notches. He dabbled in the oil business, like thousands of other Texans in the 1920s, and was publishing *Tom Hickey's Magazine* in Fort Worth at the time of his death from throat cancer in 1925.

# AD AND PLINKY TOEPPERWEIN

*The Best There Ever Was*

T he St. Louis World's Fair may have been the first time Ad (1869–1962) and Plinky Toepperwein (1882–1945) performed in public as husband and wife, but the couple from the Lone Star State wowed the matinee audience on May 14, 1904, with their trick-shot artistry.

Born in Boerne during the post–Civil War occupation, Adolph Toepperwein was raised by his German immigrant parents at Leon Springs on the outskirts of San Antonio. With a gunsmith for a father, the boy became proficient with firearms at a very early age. At six, his father made him a crossbow, and by eight he was a better shot with a fourteen-gauge shotgun than most grown men.

Ad was just thirteen when his dad's sudden death made schooling a luxury his widowed mother could not afford. The lad found work at a pottery shop to help her keep a roof over their heads.

Later that year, Buffalo Bill's Wild West Show came through the Alamo City with Doc Carver, the celebrated marksman with the shoulder-length locks. Widely acclaimed as the greatest shot alive, he also was billed as "the most handsome man who ever held a gun."

The dazzling deadeye inspired young Ad to take shooting seriously, but practice meant shells—lots of them. To keep the bullets coming, he turned his ability to draw into a better-paying position as a cartoonist for the *San Antonio Daily Express*.

George Walker recognized talent when he saw it, and the twenty-year-old triggerman he hired for his local theater in 1889 had it in spades. Walker

scraped the money together to take Ad on an all-expenses-paid trip to New York, where he talked a vaudeville booking agent and a curious newspaper reporter into a live audition.

The headline in the next day's edition of the *New York World* said it all: "The Boy from Texas Who Put Shooting Galleries Out of Business at Coney Island." After two years of sharing the vaudeville stage with everything from trained dogs to sword swallowers, Ad moved up to top gun with the Orrin Brothers Circus.

Over the next eight years, the young Texan thrived on the three-ring circuit. He awed audiences in every state in the Union and south of the border as well. Following a show in a bullring down Mexico way, he was asked by a local policeman to turn three silver coins into priceless souvenirs. He was happy to oblige and never gave the favor a second thought.

It was only when Ad returned with the Orrin Brothers Circus to the same Mexican town that he learned he had performed a "miracle" on his previous visit. Outside the bullring, a starving peasant was praying for heavenly help when one of the American's souvenirs landed in her upraised hands.

Ad bid farewell to his many circus friends in 1901 after the Winchester Repeating Arms Company signed him to a long-term contract as an exhibition marksman. He still spent his time on the road except for occasional visits to the Winchester plant in New Haven, Connecticut. In 1902, he met a cartridge assembler named Elizabeth Servaty and after a brief courtship married the eighteen-year-old redhead, also of German stock.

The last thing the new bride wanted to be was a stay-at-home wife. Even though she had never fired a weapon in her life, she sweet-talked her skeptical husband into sharing his secrets.

"It sure pleased me when she took an interest in my shooting," Ad reflected in his old age. "Most women were scared of guns in those days, you know. I taught her to shoot and soon after we were married Elizabeth was part of my act on my tours, shooting one-inch pieces of chalk from between my fingers [and] shooting empty shells off my fingers."

One day during target practice with tin cans, Elizabeth invented her own nickname by declaring, "I plinked it!" From that day on, it was Ad and Plinky, although she always called him "Daddy" and he jokingly referred to her as "my current wife."

Plinky had been pulling triggers for no more than a year when Ad took her along to the Louisiana Purchase Exposition, better remembered as the St. Louis World's Fair. Although Plinky performed for free, overnight she became the star attraction as fairgoers flocked to see the next Annie Oakley.

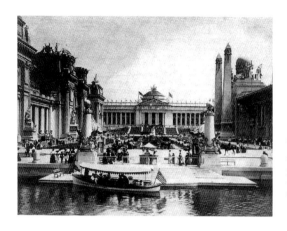

The 1904 St. Louis World's Fair drew nineteen million visitors in its eight-month run, with thousands seeing the "Fabulous Toepperweins" in action. *Wikipedia Commons.*

(Plinky and the real Oakley met only once. After watching the Toepperweins in action, Annie invited the female half of the act to her hotel room for a private conversation. Off the record, she gushed, "I didn't think it was possible for any woman to do shooting like you did!")

During their six-month run at the St. Louis fair, the sharpshooting twosome amazed and delighted packed houses several times a day. Despite her busy schedule, Plinky found time to set her first world's record for women by breaking 967 of 1,000 clay disks tossed into the air at a distance of twenty-five feet.

Winchester suddenly had a hot act on its hands and wasted no time in exploiting the couple to the hilt. Typical of the company's promotional campaign was this passage from an advertising brochure:

> *Seeing the Topperwein shooting exhibition is like going to a circus—a rapid succession of thrills and exciting feats, each more unbelievable than the one before, presented to you by this marvelous pair of shooters with rifle, pistol and shotgun. These gun wizards put on a program full of variety from the opening gun until the last shot is fired. They shoot all kinds of objects from every imaginable position—with rifle, pistol and shotgun.*

As "The Famous Topperweins" (the first "e" was dropped to make their name look less foreign), the devoted duo toured North America for the next four decades until Plinky's death from a heart attack in 1945. Late in his own long life, Ad reminisced about their wonderful times together. "Man! Those were the days! Whole towns turned out to see us perform. Schools were closed in order that the kids might come and witness the crack-shooting exhibitions."

During the same interview, which he gave at the age of eighty-eight, Ad listed Plinky's records:

*Her best pistol score* [was] *100 consecutive shots fired into a five-inch diameter spot at 25 yards. Best rifle score on flying targets was 1,460 straight hits on two-and-a-half inch wooden blocks thrown into the air 25 feet from her firing position. At Plinky's first attempt at trap shooting at the old DuPont Gun Club in St. Louis, she scored 86 of 100. She was the first woman ever to score a perfect 100 at clay pigeons. Later she scored 200 straight 12 times and later rung up 367 consecutive hits.*

Ad paused for a sip of water before wrapping up his recitation. Right up until the day she died, Plinky was the premier female shooter with shotgun, rifle and pistol. Firing a .38 Colt at twenty-five yards, she once hit the bull's-eye 497 times out of 500.

Ad was, of course, quite the record-setter in his own right. He described in riveting detail the fabled feat he accomplished over ten cold and dreary days on the San Antonio fairgrounds in 1907. Shooting seven hours a day with a lunch break, he fired 72,500 rounds from three different Winchester .22-caliber rifles at two-and-one-quarter-inch flying blocks of pine. He missed a grand total of 9, a fantastic mark that still stands over a century later.

In a lengthy interview given in his old age, Ad recalled the crowning achievement of his career:

*I will admit that when I saw the big pile of blocks which had been delivered to the fairgrounds, I had some misgivings. Would I be able to go through with it? And I did not sleep very well that night. Yet I was in perfect physical condition and perfect shooting form for I had been shooting daily for a number of years.*

*Promptly at nine o'clock on the 13th* [of December] *I fired my first shot. I continued to shoot until 12 o'clock, when we stopped for an hour for lunch and a little rest for my target throwers. We resumed the shooting again at one o'clock sharp and continued shooting until five o'clock that afternoon. I followed this schedule and program accurately for the next ten days. I did not shoot over seven hours a day on any day, with the exception of the last day when I only shot for five and a half hours. I had shot up every cartridge I had and all that I could purchase in San Antonio.*

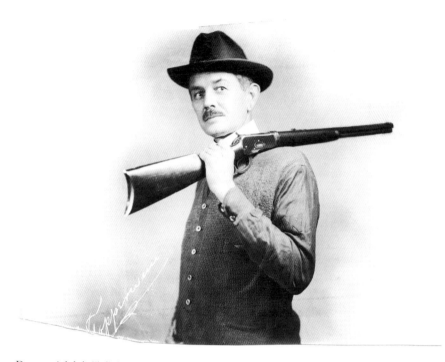

Dapper Adolph "Ad" Toepperwein and his wife and partner, Plinky, amazed audiences with their remarkable marksmanship. *RG05F968-01, Houston Public Library, HMRC.*

*On the 20th, I had my worst day when I missed four targets. The weather during the entire ten days was very bad, cloudy and chilly, with three days of almost continued drizzle rain, which did not help matters much. One of the boys offered me his raincoat, but I was afraid that it would hamper my shooting, so I took my medicine while spectators stood about under umbrellas and nearby shelters.*

The last days of the marathon were pure hell for Ad. "I was in constant physical misery. My arms and shoulders ached, the muscles of my neck pained me and I felt like somebody had pounded me all over the body. To add to this, the fingers and the wrist of my right hand cramped and caused me a great deal of pain.

"Finally, one of the boys suggested some hot water. They made a fire and put on a pail of water into which I put my hand frequently to relieve the pain." This home remedy and nightly rubdowns from his worried wife provided some relief, but it succeeded only in slowing his physical deterioration. "For the last two nights, I had been so stiff and sore that

Plinky had to undress me. I couldn't lower my arms below the waist and my shoulders were swollen and tightened."

Even though the ninth day was "pretty much a blur," Ad posted a perfect score, hitting eight thousand blocks without a miss. "But I knew when I got home that night that I couldn't go on much longer."

> *The tenth morning the boys had to help me to the firing line. The officials asked me if I was able to continue and I said, "Sure!"*
>
> *I don't remember much of the morning [but] a hot lunch revived me some and I went back at it again after a short rest. I fired my last cartridge late in the afternoon. The boys rushed up to grab me just as I started to black out a little and then I knew it was all over.*
>
> *I would have liked to have gone on a while longer to have rung up 75,000 targets, but I was very tired, the day was very dark and anyhow I was out of ammunition. So I had to let well enough alone.*

Nine misses out of 72,500 tiny targets is a super-human achievement no one has come close to equaling in more than a century—and probably never will.

Ad survived his wife by seventeen years until his own passing in 1962. Gun enthusiasts sometimes debate, as they did during their lifetimes, which of the two was the better shot. But the fact remains that Ad Toepperwein could do something neither his beloved Plinky nor anyone else has ever done. He could "draw" with bullets. His Indian chiefs in war bonnets, created on wood and other canvases in a dozen minutes or less with 450 rapid-fire shots, remain prized collector's items to this day.

# DAVID S. TERRY

## *Lost Temper One Time Too Many*

**D**avid S. Terry (1823–1889), a Texas expatriate with a bad temper, ran into a Supreme Court justice on August 14, 1889, and gave his bitter enemy a piece of his mind and the back of his hand.

Born in Kentucky in 1823, Terry was eight years old when his family moved to colonial Texas and settled in what became Brazoria County. After studying law in an uncle's office, he was admitted to the Galveston bar in 1845.

The following year, Terry went off to war with his fellow Texans. In the decade since the Battle of San Jacinto, Mexico had learned to live with the Lone Star republic on its doorstep but could not accept the long-delayed annexation of its breakaway province by the United States. In the brief but bloody second act of the conflict, which ended far worse for the Mexicans than had the Texas Revolution, Terry distinguished himself in the fighting at Monterrey as a member of Colonel Jack Hays's First Regiment of Texas Mounted Riflemen.

The young war hero thought his battlefield exploits qualified him for the office of Galveston district attorney, but the voters thought otherwise. Two years later, he came down with a bad case of gold fever and joined the Forty-Niners in the wild rush to California. As might have been expected, the pick-and-shovel routine in the gold fields did not agree with the gifted attorney, and he soon returned to practicing law.

Six years later, at the age of thirty-two, the American Party, or "Know Nothings," nominated David Terry for a seat on his adopted state's highest

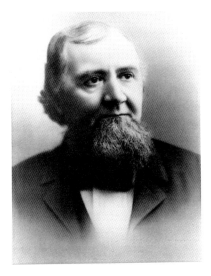

David S. Terry killed a U.S. senator in a California duel on the eve of the Civil War. *California Supreme Court.*

court. To everyone's surprise, including his own, the third-party underdog upset the favored Democrat for the prestigious post.

In 1856, the state government declared the city of San Francisco to be in a "state of insurrection" due to the activities of a "Vigilance Committee" which had taken the law into its own hands. Sent to negotiate a peaceful resolution, Judge Terry found that his judicial robes offered no protection from the out-of-control mob. During an attempted kidnapping by several armed men, he plunged his handy Bowie knife into the neck of the vigilante leader. The victim survived, as did Terry, who was freed by his captors. They had learned not to judge a book by its cover if it came from Texas.

While Terry was detained by the vigilantes, he was visited by David C. Broderick, the recently elected U.S. senator. He expressed his admiration for the judge's courage, and for a while, the two were good friends.

But their cordial relationship was doomed. After all, Terry was an outspoken advocate of Southern rights in deeply divided California, while Broderick was an equally zealous Northern sympathizer. Provoked by what he considered public insults from the politician, Terry challenged him to a sunrise showdown on the field of honor.

At their initial meeting in September 1859, a policeman showed up with a warrant for the arrest of both combatants. He took them to downtown San Francisco, where they were arraigned before a magistrate who happened to be an associate of Terry. The charge was dismissed, and the duel was rescheduled for dawn the next day.

As their respective seconds measured the ground, Broderick paced nervously back and forth while Terry stood as still as a statue with his personal physician. The two men were asked to remove their overcoats and submit to a search for body armor and "hidden deflectors." Terry's seconds undoubtedly had in mind the fact that in a previous duel, a lead ball fired by Broderick's opponent had ricocheted harmlessly off the watch in his vest pocket.

Exercising his right to select position, Broderick wisely chose to stand with the sun at his back. The choice of weapons went to Terry, who had brought along a matching pair of French dueling pistols with hair triggers.

That was Broderick's undoing. As he raised his pistol, the weapon accidentally discharged, propelling the ball into the ground just nine feet in front of him. Terry did not prolong the suspense. He fired straight and true, hitting Broderick in the chest.

According to an eyewitness account, "His right arm—the hand still grasping the pistol—was raised nearly in line with his shoulder, extended nearly full length and then fell by his side. Then his head dropped to his breast, and sinking first on his left knee, he fell to the ground."

Senator David Broderick died from his wound before the sun set on that fateful day.

Unionists mourned the slain senator as a martyr to their cause and subjected David Terry to a smear campaign, which culminated in his indictment for murder. At the 1861 trial, the presiding judge did not even let the case go to the jury, acquitting the accused on a directed verdict. Public opinion was not so easily appeased, however, and Terry was forced to resign from the California Supreme Court.

During the Civil War, the native son came home to enlist in the Confederate army. Arriving too late to fight alongside his brother in Terry's Texas Rangers, he raised and equipped his own cavalry regiment that stayed on Lone Star soil for the duration of the conflict.

After three years of self-imposed exile in Mexico, Terry went back to California and resumed his legal career. The next two decades were prosperous and free from the violence of the past, due to the steadying influence of his long-suffering wife, the niece of former Texas governor Hardin Runnels, the only politician ever to beat Sam Houston at the polls.

But Cornelia Terry passed away in December 1884; the fifth of their six children followed her to the grave three months later. Grief-stricken and lonely, the sixty-year-old widower impulsively wed a scandalous client half his age.

Sarah Althea Hill was a notorious femme fatale up to her pretty neck in a sensational lawsuit against the silver tycoon William Sharon. Insisting she had secretly married the millionaire, Hill demanded her rightful share of his fortune. The indignant defendant countered that the plaintiff had been nothing more than a kept woman and, therefore, was not entitled to a dime.

In the fall of 1886, Justice Stephen Field, newest member of the U.S. Supreme Court, read the ruling of a three-judge panel in Sarah Hill

Terry's suit. The moment she realized she had lost, Sarah went berserk. As federal marshals struggled to remove her from the courtroom, Judge Terry brandished a knife, screaming, "Let her go! I will cut you to pieces!" The ugly incident cost the couple dearly; Justice Field sentenced Sarah to thirty days in jail and her husband to six months.

On a muggy August evening in 1889, the Terrys took advantage of a train stop in Lathrop, California, to grab a bite to eat in the station restaurant. The judge found an empty table, sat down and turned toward his companion, only to discover she had disappeared.

Seeing Sarah leave the dining room in an obvious hurry, the worried proprietor politely implored Terry to stop his wife from causing a scene. Puzzled by the request, the ex-magistrate asked, "Why? Who is here?" The restaurant owner nervously nodded at the next table, where sat none other than Judge Field and his bodyguard, a U.S. marshal named David Neagle.

Leaping from his chair, Terry confronted his hated nemesis. After uttering a few well-chosen words, he backhanded Field twice across the face. Before he could slap the frightened justice a third time, Neagle drew his pistol and fired. As the Texan fell to the floor, the bodyguard shot again and was heard to snarl, "That one is for Broderick."

In spite of the incriminating fact that he murdered an unarmed man, Neagle never spent a night behind bars. The U.S. attorney general intervened on the questionable grounds that as a federal officer, Neagle was immune from prosecution by California authorities. The issue went all the way to the U.S. Supreme Court, which sided with the attorney general.

In certain vindictive circles, David Neagle was hailed as a hero. The *Nation* magazine denounced his victim as "a desperado of thirty years' standing" and added, "Somebody ought to have killed Terry a quarter of a century ago."

As for Sarah Terry, less than three years after the slaying of her spouse, she was committed to an insane asylum. There she remained under lock and key for the next forty-five years, until her own death in 1937.

# HARRY WURZBACH

*The Lonely Congressman*

A century or so ago in the Lone Star State, Republicans were rarer than Democrats are today and won even fewer elections. Given the choice, the typical Texan back then would have preferred his son grow up to be the town drunk rather than a card-carrying member of the Grand Old Party.

Instead of closing ranks and working for better times, Texas Republicans quarreled incessantly over the crumbs from the federal table. Vicious free-for-alls over petty patronage took precedence over laying the foundation for an authentic two-party system.

The divisive duel fought in the Roaring Twenties by state party chairman Rentfro Banton Creager and Congressman Harry Wurzbach (1874–1931) kept Republicans from gaining any ground. Weakened by the endless bickering, the Texas wing of Lincoln's party was lucky to escape extinction during the New Deal. An ambitious Brownsville businessman, Creager rose to power by betraying benefactors and bribing enemies with government appointments. One of the few politicians not for sale was Wurzbach of Seguin—the only Republican Texas voters sent to Congress in the first half of the twentieth century.

Creager had just become state vice chairman in 1920 when Wurzbach upset a Democratic office-holder. As the son of a respected Confederate hero, he enjoyed tremendous popularity in the San Antonio–centered district despite his partisan affiliation.

From the very start, the independent-minded congressman refused to knuckle under to the dictatorial Creager on matters of patronage. When the

tyrant ignored Wurzbach's nominees for postmaster and U.S. attorney in the Alamo City, the war was on.

By 1922, the Creager-Wurzbach feud had the party in such an uproar that the Republican president was forced to intervene. Warren G. Harding personally negotiated a truce that halted Wurzbach's denunciations of the newly named state chairman, and Creager returned the compliment by contributing to the congressman's reelection campaign.

But the cease-fire died the following year with Harding. Hostilities resumed when Wurzbach tried unsuccessfully to prevent the promotion of Creager to national committeeman, and Creager countered by opposing his rival's bid for a fourth term in 1926.

Wurzbach retaliated on the floor of the U.S. House of Representatives, where he accused his foe of demanding cash from federal office-seekers and hoodwinking the national Republican leadership with a "paper organization." Creager did, in fact, sell government jobs to the highest bidder; the state party apparatus, which he claimed encompassed 240 of Texas's 254 counties, actually included no more than 30.

The struggle took a violent turn in June 1926. Riot police were called to quell a melee that erupted at a meeting of the Bexar County executive committee. The next night, masked thugs brutally beat the congressman's campaign manager. The get-tough tactics worked to Wurzbach's advantage by creating a wave of voter sympathy. He swamped a Creager-sponsored challenger in the Republican primary and drubbed his Democratic opponent in the fall.

Oblivious to the dire consequences for Republicans—the loss of their single representative in Washington—Creager pulled out all the stops to unseat Wurzbach in 1928. The result was the longest count in Texas history.

Initial returns in early November had Wurzbach 427 votes ahead of Democrat August McCloskey. As late tallies from rural boxes and crudely amended counts trickled in, his lead gradually evaporated. When the results were finally certified two months later, McCloskey was declared the winner. But Boss Creager and his Democratic stooge celebrated their tainted victory too soon. After a yearlong investigation, a congressional committee awarded the disputed seat to Wurzbach, who went on to win his sixth term nine months later.

Creager was furious. Conceding the fact that Wurzbach was unbeatable at the polls, he resorted to a smear campaign that accused the squeaky-clean congressman of accepting illegal contributions. Before Harry Wurzbach could clear his name, a ruptured appendix suddenly cut short his career and

his life at the age of fifty-seven. Rid at last of his nemesis, R.B. Creager was free to do as he pleased.

How did the Grand Old Party fare in Texas during his thirty-year reign? Two decades went by before another Republican represented the Lone Star State in Congress, while nary a one served in the state legislature between 1931 and 1961.

For the first time since Herbert Hoover in 1928, the Republican candidate carried Texas in the presidential election of 1952, but Dwight D. Eisenhower's feat, which had nothing to do with the fact he was a Texan by birth, did not produce two-party parity. Two years later, the shorthanded GOP contested only 12 of the 150 legislative races and a mere 6 of the 22 congressional matches.

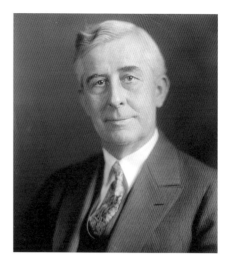

Harry Wurzbach of San Antonio was the only Republican elected by Texans to Congress in the first half of the twentieth century. *Library of Congress.*

As usual, every Republican bit the dust—everyone, that is, except handsome Bruce Reynolds Alger. The thirty-six-year old realtor and World War II bomber pilot upset the political applecart by winning the House seat reserved for Dallas County. Credit for the breakthrough went not to the victor but the vanquished, a testy former mayor of Big D. Wallace Savage angered so many liberals in the Democratic primary that most cast protest ballots for his opponent or boycotted the general election altogether. After Savage publicly spurned their support, blacks, too, stayed home, enabling Alger to spring his 53 percent surprise.

Although the brash newcomer hitched a ride on the coattails of the popular president, he did not share Ike's moderate views. Bruce Alger was a Newt Gingrich conservative when the future Speaker of the House was still in short pants.

To slim down a bloated federal bureaucracy, the Dallas native prescribed a crash diet of tax cuts, slashed spending, business deregulation and a restoration of states' rights. By consistently carrying his lean-and-mean philosophy to its logical conclusion, he earned a reputation as a right-wing radical.

Alger certainly had the courage of his convictions and never shied away from attacking federal programs that enjoyed broad support. He denounced

social security as a "shakedown" and suggested that senior citizens should turn to private charities instead of the government. As the lone dissenter in the school-milk debate, he reasoned, "If they leave our tax money back in Dallas, parents will be able to pay for their kids' lunch."

Alger was an ardent anti-communist who urged constituents to guard against the Moscow menace at home and abroad. "If we do not rally at the grass roots," he warned in a 1956 speech, "we will have a Socialist Labor government in four to eight years with a man like Walter Reuther at the head."

At the same time, however, Alger wisely kept his distance from the paranoid fringe. A foe of racial integration, he nonetheless refrained from referring to the civil rights movement as a communist plot. The John Birch Society, an influential force in Dallas during the 1950s and 1960s, may have considered him a convert, but the cagey congressman never joined the extremist group.

Alger masterfully mixed rigid ideology and pragmatic politics. He stunned fellow Republicans by refusing to campaign against his congressional colleagues, explaining he had to stay on good terms with the twenty-one Democrats in order to get anything done in Washington.

Disdainful Democrats at first dismissed the Alger upset as a fluke and predicted a prompt return to the status quo. But Henry Wade, the Dallas district attorney, suffered a stinging rebuke at the polls in 1956, as did state senator Barefoot Sanders in 1958 and Joe Pool in 1960. The next year, a college professor from Wichita Falls replaced Alger as the fair-haired boy of the Texas Republican Party. John Tower's unprecedented triumph in a winner-take-all special election to fill Vice President Lyndon Johnson's old Senate seat boosted morale and paved the way for major gains in 1962.

Alger survived the scandalous fallout from a messy divorce to post his fifth consecutive ballot-box victory, and West Texans ended his solitary vigil by sending Ed Foreman to D.C.

Democrats took their revenge two years later with an epic landslide that decimated the ranks of Republican officeholders in Texas. Voters evicted nine out of ten state legislators and both GOP congressmen, including the seemingly invincible ideologue.

The Goldwater debacle played an important part in the ouster of Alger by ex-mayor Earle Cabell, but more decisive factors determined his demise. His failure to achieve passage of a single bill or resolution during his ten-year tenure disillusioned all but his most devoted followers, and Dallas's loss of eight federal agencies underscored his inability to bring

home the bacon, convincing business leaders as well as the *Dallas Morning News* to switch sides.

The repudiation of 1964 permanently scarred Bruce Alger. The charismatic David that scared the bejabers out of the Democratic Goliath left Texas for Florida to lick his wounds. He returned to Dallas in 1976 but kept a low profile and never again sought political office. After his retirement in 1990, Alger bid Big D farewell for the last time and spent the rest of his days in Florida, where he died in 2015 at the age of ninety-six.

It is a quirk of human nature to think that what is today always was. But the current GOP would do well to remember that Republicans did not always rule the roost in the Lone Star State. They truly are indebted to two lonely congressmen, Harry Wurzbach and Bruce Alger, for holding down the fort until the political tide turned.

# MADISON COOPER

## *Wrote the Longest Novel*

A fraid that no editor would take the time to read a two-and-a-half-foot-thick manuscript, a wealthy Waco businessman mailed the first three hundred pages of his record-breaking novel to an East Coast publishing house in August 1951.

Madison Alexander Cooper Jr. (1894–1956) was born with, as he good-naturedly admitted, "at least a silver-plated spoon in my mouth." His father was a well-to-do grocer and prominent pillar of the central Texas city that would be "Matt" Cooper's home for life.

After graduating from the University of Texas with a degree in English, he fought in France as a doughboy captain. Returning in one piece to Waco, he honored his parents' wishes by taking his rightful place in the family business.

Afterhours, however, the young executive pursued a very private dream. He spent nights and weekends writing short stories and even sold a few to national magazines. But those early efforts failed to meet his high standards, and in the 1930s, he mothballed his typewriter.

Even though Cooper kept his nose to the grindstone during the Depression, he did not neglect his first love. He took three correspondence courses in creative writing from Columbia University, and this inspired his switch from the short story to the novel. Before putting a single word down on paper, Cooper thought his epic tale through from beginning to end. Allowing ten years to write, ten years to sell and another decade to edit, he did not expect to see the book in print before 1970.

Cooper's pet project was a secret he shared with no one. His elaborate precautions were so effective that even his closest friends never suspected that the plain-vanilla businessman was hard at work on the "Great American Novel."

Cooper brought the make-believe town of Sironia, Texas, to life in a small study on the third floor of the turn-of-the-century mansion he inherited upon the deaths of his parents in 1939 and 1940. A detailed map of the fictitious place and a genealogical chart with the eighty-three main characters hung on the wall behind his desk. Visitors were admitted to the sanctuary by appointment only; prior to their entering, a large map of the Lone Star State was pulled down to hide the fantasy props.

An article a few years back in the magazine *Texas Highways* described Cooper in this way:

> *A man of precise habits, living by a strict schedule of work, exercise and relaxation. He timed his appointments…and when the timer went off, the meeting was over. He only answered the phone between 8 and 11 in the morning. He turned out the lights every night at five minutes to 11 and was asleep on the hour.*

This Spartan self-discipline enabled Cooper to change hats without derailing his train of thought. "I can be in the middle of writing what I consider a poignant love scene," he once explained, "be interrupted by a tenant whose plumbing has to be repaired and then after arranging the repair I can return effortlessly to my interrupted scene."

Learning from the bitter experience of a fellow novelist who lost his life's work in a fire, Cooper typed each chapter in triplicate. He stored one copy in a closet, the second in a vacant store and the third in a bank vault.

After eleven years of tedious toil, Cooper entrusted the finished product to two student typists he swore to strictest secrecy. The finger-weary pair pounded out a manuscript two and a half feet thick! The author was stunned. He knew his novel had run a little long—but nearly 900,000 words? That was more than the Old and New Testaments combined and twice the length of Margaret Mitchell's *Gone with the Wind*.

Cooper convinced himself that no book baron in his right mind would wade through the 2,864-page manuscript. So he sent the first 300 pages to Houghton-Mifflin in the faint hope of piquing the interest of the Boston publisher. To the apprehensive author's amazement, Houghton-Mifflin immediately asked for the whole enchilada. Still believing the sheer size

In a secluded study in this Waco mansion, Madison Cooper secretly wrote the longest English-language novel in history. *Wikipedia.*

would result in rejection, Cooper mailed the next 500 pages. The response again was swift and favorable, and the repeated request for the rest of the manuscript had an air of urgency.

Cooper summoned the courage to comply and anxiously awaited the verdict. The publisher phoned in December 1951 to invite him to Boston to discuss the book, but the reclusive Texan got cold feet and begged off with the lame excuse that he was too busy to make the trip.

Weeks went by without a word from Houghton-Mifflin, and Cooper cursed himself for blowing the once-in-a-lifetime opportunity. He finally placed a long-distance call to Massachusetts, only to discover that the book was a done deal and would be printed in its record-breaking entirety.

Enough readers bought the boxed, two-volume first edition at the unheard-of price of ten dollars to put *Sironia, Texas* on the *New York Times* best-seller list for eleven weeks. That was no small feat, considering how stiff the competition was in 1952, with the publication of *The Caine Mutiny* by Herman Wouk, Edna Ferber's *Giant*, *East of Eden* by John Steinbeck and Ernest Hemingway's *The Old Man and the Sea.*

Reviews were mixed. While most professional critics attributed the attention *Sironia, Texas* received to its length and not the quality of the writing, the *Chicago Tribune* called it "something of a masterpiece" and the *New York Post* ranked it "several notches above *Gone With The Wind*."

Cooper basked in the glow of his hard-earned acclaim, which included several literary awards, such as the coveted McMurray Bookshop Award from the Texas Institute of Letters. There also was the personal pride he took in the fact that he had beaten his timetable by eighteen years.

After what it cost to print and market *Sironia, Texas*, Houghton-Mifflin understandably felt Cooper owed them another book. He paid his debt with a second work of fiction, *Haunted Hacienda*, which hit bookstores in 1955. The 303-page novel, a short story compared to his history-making opus, soon ended up in the bargain bin. The disappointed publisher took a pass on the next two parts of what Cooper originally envisioned as a trilogy.

On September 28, 1956, Cooper drove his Packard to Waco Municipal Stadium for his thrice-weekly jog around the cinder track. When he did not come home on time, his longtime housekeeper, Bertha Lee Walton, phoned the police. After all, her punctual employer had never been late for anything in his life. The patrolmen who took the call found Cooper in the front seat of his car, dead from a heart attack at the age of sixty-two.

People being people, Wacoans had spent the previous four years looking for their ancestors among the imaginary inhabitants of Sironia, Texas, despite the author's emphatic assurance that he did not base any characters on real individuals, living or dead. Any hope they entertained of a posthumous solution to the mystery went up in smoke when all of Cooper's files and personal papers were burned as he had specified in his will.

Waco's most eligible bachelor left his entire $3 million estate to the Cooper Foundation he had established thirteen years earlier in memory of his mother and father. He also bequeathed the family mansion to the charity, with the stipulation that his housekeeper would stay on the payroll as caretaker. In the decades since Matt Cooper's death, the Cooper Foundation has handed out more than $20 million in grants to a variety of worthy local causes in pursuit of its goal "to make Waco a better place in which to live."

# EARLE B. MAYFIELD

*Texans Elect Klansman to Senate*

C oming out of mothballs in October 1920, the Ku Klux Klan spread like wildfire across the Lone Star State. More than 200,000 Texans—roughly one in every dozen white adults—were suckers for the secret order's sales pitch, which exploited their nostalgic reverence for the old Confederacy and vague desire for a moral housecleaning.

In pledging their allegiance to the KKK, most members were willing to tolerate a certain degree of violence to keep blacks in line. What they did not bargain on was that their white friends and neighbors would be the nightriders' favorite targets.

The Beaumont Klan boldly boasted of their vicious attack on a doctor suspected of performing abortions. In a four-thousand-word statement published in the local papers, they gloated, "The eyes of the unknown had seen and observed the wrong to be redressed. The lash was laid on his back and the tar and feathers applied to his body."

At Timpson in Shelby County, a man was badly beaten for leaving his wife. A woman in nearby Tenaha was stripped naked, whipped with a wet rope and tarred and feathered because she was rumored to be a bigamist. A mob chased two freshly tarred victims up Congress Avenue in the heart of Austin, and a Brenham resident was pummeled for speaking German in public. Alleged immorality earned the lash for a Mineral Wells constable and a Marshall clerk, while the tar-and-feathers cure was twice prescribed for a Fort Worth gambler who failed to see the light after the first dose.

The Dallas chapter, or Klavern, the largest in the state with a membership of thirteen thousand, specialized in flogging. In the spring of 1922, sixty-eight people were whipped to within an inch of their lives in the Trinity River bottoms.

Houston Klansmen were the most accomplished spies. They kept tabs on almost everybody—tapping telephones, reading telegrams and opening mail at the post office. Their Denison cohorts combated premarital sex by patrolling lovers' lanes in white sheets.

Law enforcement at the city and county levels was honeycombed with KKK sympathizers and activists. Few Klan-related crimes were ever solved, and rarely did the perpetrators stand trial.

When Waco police arrested three Klansmen, the grand jury refused to indict, despite an airtight case. At Goose Creek outside Houston, a gang of cross-burners dragged a woman from her sickbed and mercilessly beat her

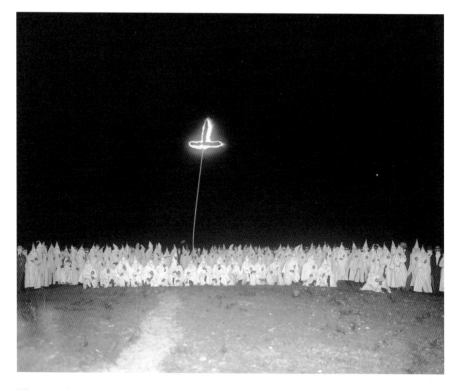

Klansmen loved to get dressed up in hoods and sheets for cross-burning rituals. This one could have taken place almost anywhere in the 1920s. *Library of Congress.*

and a male visitor. After a dozen Klansmen got off with hundred-dollar fines for the savage assault, a KKK publication bragged, "It cost Goose Creek just $1,200 to clean up."

By 1922, Texas Klansmen were feeling invincible and ready to flex their muscles at the polls. Charles A. Culberson's ill-advised decision to seek a fifth term in the U.S. Senate presented them with the perfect opportunity to show how politically powerful they really were. Alcoholism and Bright's disease had earned Culberson the derisive nickname "the sick old man of the Senate." Nevertheless, the out-of-touch incumbent seemed determined to die on the job and announced that he would stand for reelection.

With the decrepit senator literally on his last legs and totally dependent on stand-ins to do his campaigning, there was no shortage of challengers. Two early aspirants destined to fade in the stretch were Fort Worth newspaperman Clarence Ousley and Cullen F. Thomas, a former Waco prosecutor who now called Dallas home. Ousley entered the race only because better-known Wilson Democrats chose to stay on the sidelines, while Thomas sought to capitalize on his prohibitionist credentials.

The estimated 100,000 votes under Klan control tempted two avowed members of the "Invisible Empire" into throwing their hoods in the ring: Big D oilman Sterling Strong and ex-congressman Robert L. Henry of Waco. They were soon joined by fellow Klansman Earle B. Mayfield (1881–1964), who prudently preferred to keep his sheet in the closet.

Born in Overton, Mayfield received his undergraduate degree from Southwestern University before going on to the University of Texas to study law. After law school, he moved to Meridian and at the age of twenty-five became the youngest state senator ever. Six years later, the up-and-comer won a spot on the powerful Texas Railroad Commission, where he had been for the past decade.

Klan leaders believed that Mayfield was by far their best hope but hesitated to tell Strong and Henry to fold their tents. In a wait-and-see compromise that merely postponed the inevitable, all three "Klanidates" were allowed to remain in the race.

Meanwhile, a familiar figure turned the election into a referendum on the nightriders. Though banned for life from holding state office, James E. Ferguson was free to do as he pleased in the federal arena. The impeached ex-governor threw down the gauntlet to the KKK: "Your arrogated mission to save the American republic with an invisible empire is so plainly the idea of a foolish fanatic that sometimes I don't blame you for wearing a mask."

The Ku Klux Klan and Jim Ferguson's political enemies sent Earle B. Mayfield to the U.S. Senate. *RGD5F968-02, Houston Public Library, HMRC.*

The ferocity of the Ferguson attack convinced Klansmen that three candidates was a luxury they could not afford. A secret survey taken in mid-June showed that Mayfield was the overwhelming choice of the rank and file. He was quickly certified as the official standard-bearer, and his two rivals were ordered to drop out of the race. Strong obligingly obeyed, but Henry defiantly declined to withdraw. Instead, he echoed Ferguson's call for Mayfield to come clean about his Klan affiliation. Realizing that the truth could cost him crucial support, Mayfield continued to refuse to confirm or deny his membership, arguing the KKK was not an issue.

Ferguson came up with an ingenious way to remind the electorate of Culberson's poor health and prolonged absence from the Lone Star State. If the intoxicated invalid returned to Texas, where he had not set foot in ten long years, and gave two twenty-minute speeches, "Farmer Jim" promised to pull the plug on his own campaign. A Culberson aide later admitted that the inability of the sickly senator to call Ferguson's bluff doomed him to defeat.

Mayfield was the top vote-getter in the July 22 Democratic Party primary, but Ferguson qualified for a runoff with an impressive second-place showing. Culberson came in third, trailed by Thomas and Ousley. Die-hard Henry brought up the rear.

Forced to choose between a cross-burner and a disgraced former governor, many Texans picked Mayfield as the lesser evil. All that mattered to prohibitionists like Senator Morris Sheppard, author of the Eighteenth Amendment, was his public commitment to the dry crusade. Culberson declined to take sides in the second primary, as did Governor Pat Neff, but William P. Hobby, Neff's predecessor and Ferguson's replacement, backed Mayfield "in keeping with the progress of democracy and the forward march of Texas."

Ferguson, with his usual no-holds-barred style, targeted both Mayfield and Hobby in an especially memorable attack. He accused them of getting "drunk as boiled owls" at a party three years earlier and jogging naked along the banks of the San Gabriel River. The war of words ended on August 26 with a 54 percent victory for Mayfield. Two hundred and sixty-five thousand Texans turned out for Farmer Jim, but he was no match for the unholy alliance of Klansmen and prohibitionists.

Dissident Democrats staged an independent protest in the fall with the write-in candidacy of a young district attorney stripped of his Sunday school duties after casting a ballot for Ferguson. Mayfield beat George Peddy better than two to one even after divulging under oath that he had indeed belonged to the Klan until late January.

While Mayfield waited to take his seat in the U.S. Senate—a process that took two years—Texans came to their senses. Led by former lieutenant governor Martin Crane and Congressman John Nance Garner, more and more elected officials began speaking out against the KKK. A judge in Wichita Falls jailed three Klansmen for contempt, and the mayor of Dallas condemned their sinister shenanigans. Chambers of commerce, Masonic lodges, American Legion posts and the state bar association also joined the critical chorus. The *Houston Chronicle* added its influential voice to the outcry with this sound piece of editorial advice: "Boys, you'd better disband."

Dan Moody set a courageous example for district attorneys across the state. After a traveling salesman was kidnapped, chained to a tree and flogged half to death in Taylor, the prosecutor unmasked the midnight maniacs, including a minister and the police chief, and sent one to prison.

Authorities in Laredo prevented a Klan march by deputizing one hundred armed citizens and borrowing a machine gun from the army. Rocks and fists caused Klansmen to cancel similar plans in McKinney, and strict enforcement of a local ordinance banning masked mobilizations rained on a proposed parade in San Antonio.

The "visitation," the Klan's curious practice of interrupting a church service to lecture the captive congregation, began to backfire. Baptists in Denison and Austin forcibly ejected the intruders, and Corsicana Presbyterians supported their pastor's fearless refusal to join the KKK.

Only two years after electing one of their own to the U.S. Senate, the Texas Klan was repudiated at the polls in 1924. Miriam A. Ferguson defeated Felix D. Robertson in a bruising gubernatorial battle and knocked the wheels off the Klan bandwagon.

The new legislature passed a tough anti-mask law by lopsided votes in both chambers. The vast majority of Klansmen got the message and deserted the Invisible Empire, leaving only a handful of hateful diehards to crawl back under their rocks.

Despite the undeniable fact that the KKK was clearly on the skids in 1928, Earle B. Mayfield had the gall to ask for six more years in the Senate. Congressman Tom Connally made him a one-term fluke, but even that rebuke did not keep the closet Klansman from running for governor two years later. Finishing a humiliating seventh with just 6 percent of the vote, Mayfield went into permanent political retirement.

# 20
# JAMES PINCKNEY HENDERSON

## *First Governor of Texas*

James Pinckney Henderson (1808–1858) rode into Austin on February 16, 1846, three days ahead of the ceremony that swapped sovereignty for statehood and certified the former diplomat as the first governor of Texas.

Born in the Tar Heel State, Henderson studied law at the University of North Carolina and became a licensed attorney at twenty-one. Chronic health problems stemming from an incurable case of tuberculosis mandated his migration to Mississippi, where, in late 1835, he heard about the uprising in the Mexican province of Texas.

Although Henderson arrived six weeks too late to fight, he must have made a heck of an impression on the "Hero of San Jacinto." President Sam Houston invited the sickly young lawyer to join his cabinet as attorney general, a post he held for barely a month before switching to secretary of state after the premature passing of Stephen F. Austin.

Houston was not alone in his high opinion of Henderson. Oran Roberts, future governor and chief justice of the state's highest court, wrote: "Henderson was one of those magnetic men that impress you at first sight as being of no ordinary stamp. He was tall and rather delicate in appearance, with light hair, fair complexion, and fine gray eyes; affable, and sparkling all over with genuine vivacity."

Henderson was sent abroad in 1837 to secure European recognition of the brand-new North American nation and to establish the commercial ties so vital to the survival of the struggling republic. Forced to wing it with little guidance from Houston or his successor, Mirabeau Lamar, the one-

Practiced Law

Stars and Stripes
Over the Old Capitol

—Text by William H. Gardner, Drawings by Bud Bentley

The artist captured the delicate features of James Pinckney Henderson, first governor of Texas, in this editorial page sketch. Houston Post, *May 9, 1961, Houston Public Library, HMRC.*

man foreign service successfully negotiated trade agreements with England and France and persuaded both powers to publicly acknowledge Lone Star independence.

While in Paris, Henderson met a Philadelphia socialite with an extraordinary head on her shoulders. Frances Cox was fluent in two dozen languages, played the piano and was sufficiently well versed in the law to run her future husband's office during his frequent absences. They married in London in October 1839 and the following year set up housekeeping in a log home in San Augustine, where the bride donated $7,000 for the construction of the Episcopal church.

This peaceful interlude, during which Henderson concentrated on his law practice and his new family, was suddenly interrupted by a Piney Woods outlaw hell-bent on taking his life. The popular attorney had never laid eyes on the homicidal stranger, nor did he ever discover his motive.

Looking back several years later on that disturbing chapter in his life, Henderson divulged the details in a letter to a friend:

> *I had been annoyed for more than a year by a desperado named N.B. Garner. He had threatened to kill me and twice when I was unarmed he attempted to assassinate me.*
>
> *I had an abhorrence to the shedding of human blood in a street fight and labored to avoid it as it never in my estimation adds to a man's reputation.*

But, as Henderson went on to explain, his foe backed him into a corner. "A few days before I killed Garner, he waylaid me with a double-barreled gun to assassinate me as I passed, but I learned his movements and avoided him. He was preparing to shoot me when I shot him."

"I regret that the beast forced me to do that which some ruffian ought to have done but I shall never regret that I killed him as I am sure he would have killed me if I had not slain him."

Henderson stood trial for the murder but was found not guilty on the grounds of self-defense.

Kenneth Anderson, last vice president of the republic and Henderson's law partner, was considered a cinch for governor in the summer of 1845. But after the unexpected death from malaria of the front-runner, his backers rallied around Henderson, whose name had never appeared on a ballot, as the most suitable substitute. Two months of begging and pleading wore down his resistance, and he reluctantly announced his candidacy in early September.

The December 15 election was just seven weeks away when Henderson finally drew an opponent. Dr. James B. Miller of Fort Bend County was a serious contender, having served in Houston's second cabinet, the Republic Congress and the recent annexation convention. Political prognosticators predicted a tight race, and more than a few gave the physician the inside track.

No one was more surprised by Henderson's landslide victory than the first-time office-seeker himself. Unbelievably lopsided returns from eastern counties like Rusk (271–1), Harrison (747–1) and Nacogdoches (711–0) gave him a four-to-one advantage in the final count.

Two months after Texas officially entered the Union and Henderson was sworn in as the first governor, the inevitable war with Mexico broke out. General Zachary Taylor called for volunteers, and Texans answered with three regiments—two on horseback and one on foot.

Despite being under the weather, as usual, Governor Henderson insisted on leading his constituents into battle with their mortal enemy. On May 9, obliging legislators granted his request for a fighting furlough, and ten days later, he left for the front, leaving the lieutenant governor temporarily in charge.

As it turned out, Albert C. Horton could only twiddle his thumbs until Henderson's triumphant return in November or December—historians disagree on the exact date—because the state legislature adjourned the same week as the warrior governor went off to war.

A second term was his for the asking, but Henderson flatly refused and this time would not budge. He privately endorsed Isaac Van Zandt, a friend and fellow diplomat from the days of the defunct Republic. However, his death from yellow fever ensured the election of Colonel George T. Wood, Indian fighter and Mexican War hero.

Henderson moved from San Augustine to Marshall in 1856, and the next year he stumped for Hardin Runnels in his gubernatorial upset of Sam Houston. Consistent with the custom of the time, the former governor followed the former president from event to event, presenting the opposing viewpoint after each and every speech.

During the campaign, Henderson lost a second law partner and Texas a U.S. senator with the shocking suicide of Thomas Rusk. On November 9, 1857, state lawmakers passed over a host of ambitious applicants in favor of a respected figure living on borrowed time.

Henderson undoubtedly knew he would not live to complete Rusk's term, which had two years to go, but surely figured he would last longer than three short months. Exhausted by the long trip to Washington, D.C., the following March, he rapidly weakened and died on June 4, 1858, at the age of fifty.

Don't go looking in the Texas state archives for the gold-hilted sword the U.S. Congress awarded to James Pinckney Henderson for his gallantry in the Mexican War. His daughter Frances took it with her when she married a Prussian baron, and her aristocratic Austrian descendants have held on to it to this day.

# BUCK BARRY

## *A Life Full of Adventure*

A ll too often, early settlers of Texas are portrayed as illiterate fugitives. Not so with the well-known Texas Ranger and Indian fighter James Buckner Barry (1821–1906), who possessed a better than average education for those days and was running to an exciting land full of opportunity rather than from the law.

Twenty-four years old when he left his Tar Heel home, Barry spent a month at sea before finally docking at New Orleans. He had to wait a week before boarding a ship bound not for Galveston but an inland port of entry on the Red River.

Jefferson was not much to look at on April 12, 1845, the day Barry first set foot in Texas. As he recalled in his memoirs half a century later, "Several houses were under construction but there was only one finished."

The newcomer did not linger long at the future bed-and-breakfast haven. He wandered west through the wild countryside with his ultimate destination San Antonio. On his way to the Alamo site, he visited the latest and last capital of the Texas Republic. Austin was still in its infancy and offered the traveler little more than did Jefferson. Barry clearly was not impressed. Other than the capitol building, "Austin had only a few houses built of logs, clapboards and whipsawed lumber," he wrote many years later. "I recollect seeing only one white woman in town, if it could be called a town."

A short time later, Barry "joined the little army of the Republic of Texas, numbering 250 men, commanded by Major [John Coffee] Jack Hays." He was assigned to a squad of ten headquartered "on the Trinity River,

Buck Barry is seen here in his youth, soon after coming to Texas. *DeGolyer Library, Southern Methodist University, Lawrence T. Jones Texas Photographs.*

something like halfway between where Dallas and Fort Worth have grown to be cities."

Of all his memorable experiences as a Texas Ranger on patrol, none stood out quite like a strange sight in a snowstorm. "We saw a horse at a distance standing still with a saddle on. We found his rider frozen to death with a noose of the bridle reins around one wrist."

In the spring of 1846, Barry and his comrades invited a passerby to breakfast. That was how they learned war with Mexico was about to break out on the border. Jack Hays saved a place for the North Carolinian in the First Texas Mounted Rifles, a regiment made up of Rangers and other hard-fighting frontiersmen. Membership in the unit was Barry's ticket to nearly every major battle and a front-row seat for an unforgettable incident.

Bright and early one morning, a detachment of Mexican lancers surprised the sleeping Texans. To give his men time to wake up and make ready for battle, Hays "rode out front with his saber in hand and challenged the colonel of the lancers to meet him halfway between the lines to fight a saber fight." The enemy officer "advanced waving his saber, while his horse seemed to dance rather than prance. Within a few feet of the Mexican, Hays pulled a pistol and shot him dead from his horse."

The lancers "charged us like mad hornets" making three daring passes through the Texan lines. Marveling at the courage of the enemy soldiers, Barry wrote, "I have never called a Mexican a coward since."

After the one-sided war, it was briefly back to North Carolina for Barry and marriage in 1847 to the sweetheart who had waited for him. The newlyweds set up housekeeping south of Dallas in Navarro County, where voters drafted the office-shy breadwinner for three terms as sheriff and one as county treasurer.

In late 1855, Barry moved to Bosque County on the edge of the frontier. But plans of spending more time with his growing family were spoiled by the depredations of "reservation Indians" from their government-protected sanctuary on the Brazos.

Barry devoted the next decade, including the Civil War, to fighting Indians and retrieving the horses and human captives taken on their raids. He eventually succeeded in bringing about the relocation of the troublesome tribes north of the Red River, thereby averting all-out war between the Texans and the U.S. Army.

The *Handbook of Texas* rarely gets anything wrong. An exception to this reliable rule is the assertion that Barry took part in the Battle of Dove Creek, where for once the Indians won. He spent a whole chapter of his autobiography on the 1865 clash near present-day San Angelo, but every bit of his information was secondhand.

Dove Creek was one of those frontier fights between Texans and Indians that never should have happened. An unusually large band of Kickapoos numbering in the hundreds was merely passing through West Texas en route to Mexico, where they could safely sit out the white man's Civil War. But

the hysterical overreaction of the state militia or "home guard" and the commanding Confederate officer at Fort Chadbourne set the stage for a tragic confrontation.

After the Texans caught up with the Kickapoos and were making final preparations for their attack, a tribal elder appeared to plead his people's case. They were "friendly Indians," he explained, whose sole desire was safe passage to Mexico. Henry Fossett, the Confederate captain, retorted that any Indian caught in Texas was by definition up to no good. He had the emissary executed on the spot.

By that time, the militiamen were already wading Dove Creek in a suicidal storming of the Kickapoo defenses. From the dense brush on the opposite bank, as many as one thousand warriors opened fire with Einfield rifles, killing eighteen part-time soldiers and seriously wounding fourteen others. Fossett and his regular troops escaped a similar ambush with minor wounds but found themselves pinned down by a cleverly conceived crossfire.

The Indians pulled back after sunset, allowing their helpless opponents to slip out of the trap. The uniformed Rebs and their plainclothes companions owed their lives to a wise Kickapoo chief.

Common sense rather than compassion dictated No-Ko-Wat's decision not to slaughter the whites. He knew a massacre would have meant annihilation of the Kickapoos, because Texans never let a bloodbath go unavenged.

Captain Fossett and his militia counterpart colored their reports of the Dove Creek debacle in a clumsy attempt to save face and salvage their reputations. Both minimized the scope of their humiliating defeat and wildly exaggerated the losses suffered by the other side.

The record was eventually set straight by an Austin newspaper, which published an Eagle Pass interview with No-Ko-Wat. Readers were shocked to learn that his dead totaled fourteen instead of the hundreds claimed by Fossett and the militia leader.

In his memoirs years later, Barry included a previously unpublicized episode that cast the Dove Creek militiamen in an even worse light. While tracking the Indians, they opened the fresh grave of an adult female in order to determine the identity of the tribe. Several Texans, over the protests of their fellow militiamen, plundered the grave, taking articles of clothing and jewelry as souvenirs.

The looters laughed off the warning of "bad medicine" from their comrades, who insisted that even an Indian grave deserved respect. Barry ended the chapter with this chilling conclusion: "But the men encountered no visible results of their ghoulish act until the battle, a few days later, with

Four generations of Barrys, with old Buck (*far left*) sporting a long white beard. *DeGolyer Library, Southern Methodist University, Lawrence T. Jones Texas Photographs*.

these Indians they were trailing, when every possessor of a trinket met death in the fight."

The familiar figure with the shoulder-length hair and fondness for buckskin dabbled in politics in the 1880s and 1890s, first as a prominent supporter of the Grange and later with the People's Party.

After a failed bid for state treasurer in 1898, Buck Barry retired to his ranch near Walnut Springs. He completed his autobiography, published in 1932, before going totally blind and dying on his eighty-fifth birthday in 1906.

During his campaign for state office on the People's Party ticket eight years earlier, many of his neighbors issued a signed statement in support of his candidacy. It could have served as the frontiersman's eulogy:

*He has been in more fights and killed more Indians with the same force than any other officer that was ever on the frontier…and for which the twelfth legislature honored him with a gun, which relic he yet possesses.*

*During his services on the frontier he and his command recovered more than fifteen hundred head of horses from the Indians they had stolen from the settlers, and he sent them to the settlements, and had them advertised, which enabled the people to get their horses.*

*The most of us have lived almost neighbors to Colonel Barry for nearly fifty years and some of us were with him in his desperate struggles with the Indians and knowing him as we do, and the many risks he has run of losing his life in protection of the helpless women and children from the inroads of the Indians and outlaws, cause us to feel under many obligations to him; and we believe the people of Texas owe him more than any other man now living in the state.*

How nice it must have been for old Buck Barry that he did not have to wait until he was dead and buried to hear such a heartfelt tribute.

# EDWARD MANDELL HOUSE

## *The Colonel Behind the Curtain*

Few disagree on what can be called the "Big Three" of Texas politics in the twentieth century. John Nance Garner of Uvalde spent thirty years (1903–33) in the U.S. House of Representatives, including fifteen months as Speaker of the House and eight years as Franklin D. Roosevelt's first vice president, a job crusty "Cactus Jack" famously said was "not worth a pitcher of warm spit." "Spit" was not, of course, the colorful word he chose. Sam Rayburn of Bonham was a member of the House for almost half a century (1913–61), during which he served a record seventeen years as Speaker. Lyndon Baines Johnson was one of only four Americans elected to the House, the Senate (where he was majority leader for six years), the vice presidency and the presidency.

But to this list of "master politicians" must be added a frail and diminutive Houstonian who shunned the limelight like the plague and never sought nor held public office. But he was every bit as good at "playing politics." Edward Mandell House (1858–1938) was born in the Bayou City on the eve of secession and the Civil War. He was the last of seven children—all boys.

His father was, to put it plainly, a war profiteer. Thomas William House made a fortune running the Union blockage, taking cotton out to foreign markets and bringing in munitions, clothing and medicine he sold at inflated prices to the Confederate army. By the end of the war, he was one of the richest men in Texas, with sugar and cotton plantations, banks and a variety of profitable enterprises.

Edward was a normal, active and rambunctious boy until a freak accident at the age of twelve. He was swinging as high as the treetops when a rope broke, sending him headfirst into a carriage wheel. It was touch-and-go for a while, with doctors telling the heartsick parents, who had recently lost another son in a similar mishap, to prepare themselves for the worst. Weeks went by before the attending physicians finally announced that the youngster would pull through, amazingly with no brain damage.

Edward endured an agonizingly slow recovery, made even slower by a bout with malaria, along with yellow fever, one of the twin scourges of Reconstruction Houston. Many months went by before he was allowed at last to get out of his sickbed. It was then that the boy discovered he no longer had the strength and stamina to keep up with his brothers. For the rest of his life, he would be a sickly person who tired easily and could not tolerate the heat and humidity of his hometown.

Edward was in his sophomore year at Cornell in upstate New York when his father died. (His mother had passed away two years after his life-changing collision with the carriage.) The patriarch left an estate valued at half a million dollars, a stupendous sum for 1880 and the third-largest private fortune in the Lone Star State.

Edward saw no reason to return to college, and he never did. Even though he was the "baby of the family," in a matter of months he assumed complete responsibility for the management of all the House holdings and businesses, with the apparent blessing of his older brothers.

During his twenties and early thirties, Edward developed a keen interest in state politics. In 1886, he moved to Austin with his wife of five years in order to study the subject more closely and to invent a behind-the-scenes role for himself.

In 1882, House offered his untested services to Governor Jim Hogg, whose reelection bid had turned into the fight of his political life. A breakaway Democrat named George Clark had formed a third party with the support of both Republicans and Populists for the sole purpose of denying Hogg the traditional second term. Young House's tactical advice, which emphasized playing down Hogg's perceived radical streak, turned the tide for the embattled incumbent.

House's part in the Hogg comeback got him exactly what he wanted—a seat at the table in state politics. He went on to groom and guide the next three successful gubernatorial candidates: Charles Culberson in 1894 and 1896, Joseph Sayers in 1898 and 1900 and S.W.T. Lanham in 1902 and 1904. The only thing worth noting about Sayers and Lanham is that they were the

Colonel Edward Mandell House as he looked during President Wilson's first term. *MSS399-1, Houston Public Library, HMRC.*

last Confederate veterans elected to Texas's highest office; Culberson became a four-term fixture in the U.S. Senate in spite of his alcoholism and chronic health problems.

By 1905, the "Colonel," an honorary title bestowed on House by the grateful Hogg, was bored and looking for a fresh challenge. With nothing better to do, he set his sights on putting a Democrat in the White House.

That was much easier said than done. Since the Civil War, every Democratic candidate for president had lost, except one—Grover Cleveland (1884 and again in 1892). Democrats had their hearts set on William Jennings Bryan being their party's next president and enthusiastically nominated him in 1896 and 1900, only to watch William McKinley beat him twice. Believing the third time had to be the charm, Democrats tried the beloved "Great Commoner" again in 1908, but Bryan went down to his worst defeat, losing badly to William Howard Taft.

House viewed this electoral version of the movie *Groundhog Day* with a mixture of amusement and dismay. He clung to the faint hope that Democrats might choose a candidate in 1912 with a shot at winning but soon decided not to leave something so important to chance.

While convalescing from one of his periodic illnesses in the winter of 1912, House secretly wrote a novel he later published anonymously with his own money. Entitled *Philip Dru, Administrator*, it can be seen either as an innocent utopian fantasy or as a fascinating glimpse into the mind of one of the great political thinkers of his day.

In a particularly insightful review, Billie Barnes Jensen explained:

> *Philip Dru depicted a centralized, ruthless, corrupt government. The United States of Philip Dru was controlled by two men who operated behind the scenes. One of these was Selwyn, the political boss* [and] *the second was Thor, the financier.*
>
> *In the novel, these men set up a puppet as President of the United States and were well on their way to controlling the entire nation when their secret*

*plans were made public by a clerk who accidentally acquired a recording of one of their secret sessions. The country was thrown into a panic, and the man who stepped forward to lead the national uprising in the time of crisis was Philip Dru, a brilliant military strategist, who had been forced to leave the army because of an injury.*

*... [Dru] defeated the government forces in a bloody battle and assumed complete control of the United States for a period of time during which he set up a new constitution and system of laws for the country, providing the needed reforms. With the new government in operation and with enemies abroad stilled, Dru left the country so that none would think he intended to become a permanent dictator.*

With the advantage of hindsight, some have said that *Philip Dru* was Colonel House's game plan for America, what he might have done if afforded the opportunity. Others take it a step further and contend that a careful reading of the novel reveals concrete changes carried out by the Wilson administration at the behest of his chief advisor.

House was not the first leading Texan to recognize the presidential potential of Woodrow Wilson, the college president turned politician. On the night of his election as governor of New Jersey in November 1910, Wilson received this telegram from Thomas B. Love of Dallas: "I am for you for President of the U.S. in 1912." It would be a full year before Wilson and House met face-to-face in a New York City hotel room. By that time, key members of "Our Crowd," House's clique of Austin-based cronies, had begun working to ensure that all of the Texas delegates to the National Democratic Convention would be committed to the governor.

The colonel dutifully recorded his first impression of Wilson in the diary he faithfully kept for fourteen years:

*We talked and talked. We knew each other as congenial souls at the very beginning. We agreed about everything. That was a wonderful talk. The hour flew away. Each of us started to ask the other when he would be free for another meeting, and laughing over our mutual enthusiasm, we arranged an evening several days later when Governor Wilson should come and have dinner with me.*

Sounds more like an adolescent infatuation than the start of a historic political partnership, doesn't it?

The key to the close relationship House and Wilson built in such a remarkably short time is that the Texan never openly differed with the

thin-skinned eastern intellectual. Instead, he shrewdly steered Wilson in the desired direction with flattery and skillfully worded appeals to his vanity. Wilson, in turn, liked and trusted House more than anybody else because they were of the same mind—or so he believed.

In the summer of 1912, the Texas delegation arrived at the Democratic National Convention in Baltimore "loaded for bear" with forty delegates bound by a signed pledge to hold out for Woodrow Wilson until hell froze over. One Texan who did not stand up for Wilson, at least not in public, was the "Veiled Prophet of Austin." Giving the governor "a good chance but nothing more," E.M. House suddenly remembered a prior commitment, a transatlantic cruise. As he was known to do, the colonel risked his reputation only on sure things.

The opening ballot seemed to suggest that House had made a smart move. Wilson trailed Speaker Champ Clark of Missouri by 116 votes, with Ohio governor Judson Harmon and Representative Oscar Underwood of Alabama within striking distance. When the notoriously corrupt Tammany Hall machine went over to Clark on the ninth ballot with the bulk of the New York vote, the front-runner had the majority but not the nomination. That took two-thirds of the delegates.

Neutral until that point, William Jennings Bryan, in one of his spellbinding speeches, blasted Clark as a Tammany tool and front man for Wall Street. The "Great Commoner" ended with a rousing endorsement of Wilson as the only true reformer in the field.

Wilson gradually gained ground but was still stuck in second place after the twenty-sixth ballot at three o'clock in the morning. The convention adjourned for the rest of the day, a Sunday, with plans to resume bright and early on Monday. Typical of the telegrams the Texans received on their day off was this short and to-the-point message from an East Texas Democrat: "We want Wilson. Don't come home until he is nominated."

Nonetheless, it was only more of the same on Monday. Wilson began to despair of his chances of catching Clark and even went so far as to draft a concession statement. But on the thirtieth ballot, the deadlock was broken; sixteen ballots later, the underdog became the presidential nominee of the Democratic Party.

The "Immortal Forty," a nickname the Texans coined themselves, rightly received the lion's share of the credit from none other than the future First Lady. At a post-convention celebration, Ellen Wilson gushed to Tom Love, "Oh, Mr. Love, but not for Texas we would not be here today!"

Even though he received a little less than 42 percent of the popular vote in the general election, Woodrow Wilson won in an electoral college landslide thanks to the split in the Republican Party. Former president Theodore Roosevelt, running as an independent on the Bull Moose ticket, carried six states with 27 percent of the nationwide turnout, compared to a mere two states and only 23 percent for the incumbent Taft. The remaining 6 percent was polled by Socialist Eugene Debs, the preference of more than 900,000 voters.

To show his gratitude, the president-elect told Colonel House that any cabinet post other than secretary of state, which he had promised to Bryan, was his for the asking. But the reclusive advisor politely declined, preferring to keep what he already had—the ear and trust of the next president of the United States.

In his first term, Wilson categorically refused to take sides in the "Great War" that erupted in Europe in the summer of 1914. Mirroring the antiwar sentiment of a massive majority of the American public, he maintained in word and deed a hard-and-fast position of neutrality.

Easily bored by domestic issues, House persuaded the president to send him to Europe on a quasi-official peace mission. Whether he honestly believed it was in his power to prevent the hostilities that would engulf the continent is hard to say. But House tried, shuttling between the capitals of the future combatants, and for that he earned the admiration and respect that served him well during the postwar negotiations.

The colonel lost an indispensable ally in the White House when the First Lady died of kidney failure in August 1914. Whenever her moody husband overreacted to something House said or did, she always reminded him of the debt he owed his phantom advisor. Wilson was prostrate with grief over the sudden loss of his wife, but it was obvious that he would not long remain a widower. House was not alone in cautioning him against remarrying before the 1916 election, but Edith Bolling, who became the second Mrs. Wilson in December 1915, never forgave House for opposing the nuptials.

In his bid for a second term, Wilson faced a Republican Party united behind Charles Evans Hughes, the former governor of New York. The election was a one-on-one contest without Teddy Roosevelt or the socialist Debs on the ballot. The campaign slogan "He Kept Us Out of War" made the difference in the popular vote as well as in the electoral college, where Wilson prevailed 277 to 254.

Five months later, the president stunned the country by asking Congress for a declaration of war against Germany. The United States would make

Photos like this of Edward House and French prime minister Georges Clemenceau convinced Woodrow Wilson that his friend and advisor was hogging the limelight in Paris. *Houston Public Library, HMRC.*

"the world safe for democracy," said the preacher's son. In the next breath, he warned, "If there should be disloyalty, it will be dealt with with a firm hand of repression."

Thousands of Americans who dared to speak out against the war and the draft were jailed. Wilson condemned them as "traitors," especially Debs, who was sentenced to ten years in the federal penitentiary in Atlanta. Worried at how the Wilson administration would look if the aged socialist died behind bars, Attorney General Palmer of "Palmer Raids" fame recommended a presidential pardon, but Wilson flatly refused. It was left up to his Republican successor, Warren G. Harding, to cut short Debs's imprisonment.

E.M. House did not fare much better. As Wilson's designated negotiator at Versailles, he followed the president's instructions to the letter. Nevertheless, Edith Wilson convinced the president that the colonel "gave away the farm" and hogged the limelight in Paris. The day in 1919 that Wilson left France on his return voyage to the United States, House went to see him off. That turned out to be their last face-to-face meeting.

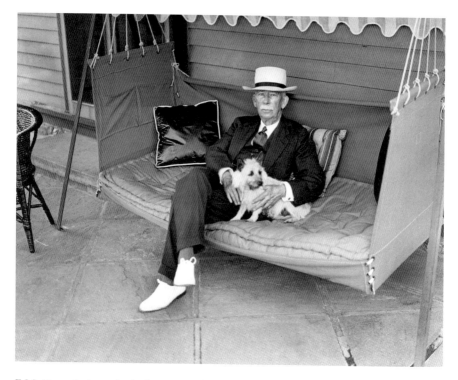

E.M. House is shown in the last years, when his devoted dog paid him more attention than President Franklin Roosevelt. *MSS399-17, Houston Public Library, HMRC.*

Wilson never fully recovered from a stroke complicated by influenza. His incapacitation, which an obliging press helped to conceal from the American people, resulted in Edith Wilson acting as the first, though unelected, female chief executive for the last year and a half of her husband's time in office.

Edith Wilson's final vindictive act was to bar Colonel House from the ex-president's funeral in 1923, just as she had banned him from her invalid spouse's sickroom. He stood alone in the rain outside the church for the entire service.

A series of Republican presidents in the Roaring Twenties denied House the opportunity to counsel another occupant of the Oval Office. Though well into his seventies when FDR was elected in 1932, the New Deal was not his cup of tea, and Roosevelt knew it. They had a few perfunctory conversations, but nothing came of it.

Edward Mandell House died in 1938 at the age of seventy-nine. Despite his political brilliance and artfully concealed accomplishments, the "Colonel Behind the Curtain" was destined to fade into obscurity.

# SOURCES

**M**ost of the chapters in *Unforgettable Texans* began as newspaper columns ten, twenty, thirty years or more ago. For that reason, a complete list of sources would take longer to exhume than it did to write this book!

However, I can steer the inquisitive reader in the right direction and offer a few valuable pointers. The starting place for learning more about any subject under the Lone Star sun is the *Handbook of Texas*. Every major player, especially those who rated their own chapter, has a detailed biography in this unique resource. In addition, you will find references to various books, articles and other sources at the end of each entry.

Available on the same website as the *Handbook* is a collection of the *Southwest Historical Quarterly* dating to the turn of the twentieth century. While the scholarly nature of some articles presents a challenge for many, it is more often than not well worth the time and effort to access this resource. The vintage editions of the *SWHQ* also provide a unique understanding of Texans' evolving view of their own history through the decades.

In the 1970s, the late historian June Rayfield Welch published two indispensable works, *The Texas Governors* and *The Texas Senators*. Over the years, I have found myself returning again and again to his insightful accounts of the lives of the history makers who held those high offices. Copies of *The Texas Governors* and *The Texas Senators* as well as of Welch's other books are scarce, but any library worth its proverbial salt should have them.

If *Unforgettable Texans* has sparked or rekindled your interest in the people who shaped our past and present, I consider it a success. A great adventure awaits in your personal discovery of the history of this land we call Texas.

# INDEX

# U

Underwood, Oscar 117
University of Texas 27,
36, 93, 99
Urschel, Charles 33, 34
Uvalde, Texas 51

# V

Van Zandt, Isaac 106
Velasco, Texas 23

# W

Waco, Texas 43, 93, 95,
96, 98
Wade, Henry 91
Walker, George 78
Walnut Springs, Texas
112
Washington, D.C. 15,
20, 23, 106
Washington-on-the-
Brazos, Texas 66
Webb, Walter Prescott
55
Wharton, John Austin
22, 23, 24, 25, 26
Wharton, Sarah Ann 23
Wharton, William Harris
22, 23, 24
Wheeler, Frank 33
Wichita Falls, Texas 52,
101
Wigfall, Louis Trezevant
12, 47–50
Wilson, Edith 118, 119,
120
Wilson, Woodrow 12,
27, 73, 75, 76,
77, 99, 116, 117,
118, 119, 120
Wood, George T. 106
World War I 18, 27, 52

World War II 17, 30,
61, 63, 90
Wurzbach, Harry 88–92

# ABOUT THE AUTHOR

**B**artee Haile has written "This Week in Texas History" for small-town and suburban newspapers throughout the Lone Star State since 1983. Thirty-four years and more than seventeen hundred columns later, it is the most widely read and longest-running feature of its kind *ever*.

*Forgotten Texans* is Bartee's fourth book for The History Press. His earlier titles include *Texas Depression-Era Desperadoes*, *Murder Most Texan* and *Texas Boomtowns: A History of Blood and Oil*.

A fourth- or fifth-generation Texan (his ancestors were lousy record keepers!), Bartee Haile lives in the Houston area with his wife, Gerri, and not far from his son Brett and granddaughter Lila.

# Floppy Lop-Ears Tries to Get "Off the Spectrum"

Written by

Rochelle Caruso Flynn

Illustrated by

Joshua Allen

*AuthorHouse™*
*1663 Liberty Drive*
*Bloomington, IN 47403*
*www.authorhouse.com*
*Phone: 1-800-839-8640*

*Published by AuthorHouse 11/05/2014*

*ISBN: 978-1-4969-0384-6 (sc)*
*978-1-4969-5099-4 (hc)*
*978-1-4969-0385-3 (e)*

*Library of Congress Control Number: 2014906723*

authorHOUSE®